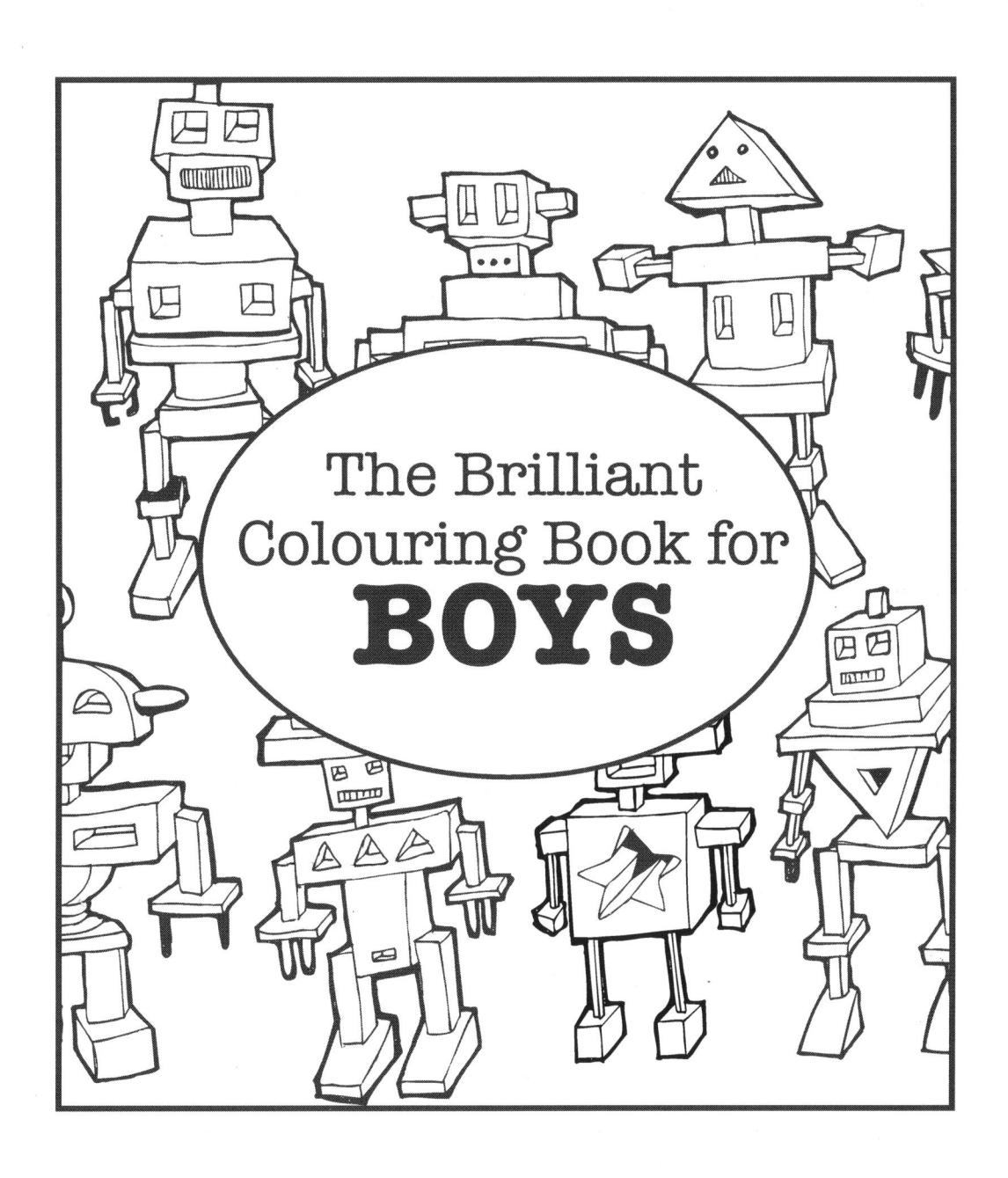

Really **Relaxing** Colouring Book

First published in 2015 by Kyle Craig Publishing

Text and illustration copyright © 2015 Kyle Craig Publishing

Editor: Alison McNicol

Cover Design: Julie Anson

ISBN: 978-1-908707-96-3

A CIP record for this book is available from the British Library.

A Kyle Craig Publication

www.kyle-craig.com

All Rights Reserved.

No part of this publication may be reproduced, stored in a retrieval system or transmitted by any form or by any means, electronic, recording or otherwise without the prior permission in writing from the publishers.

Unauthorised reproduction of any part of this publication by any means including photocopying is an infringement of copyright.

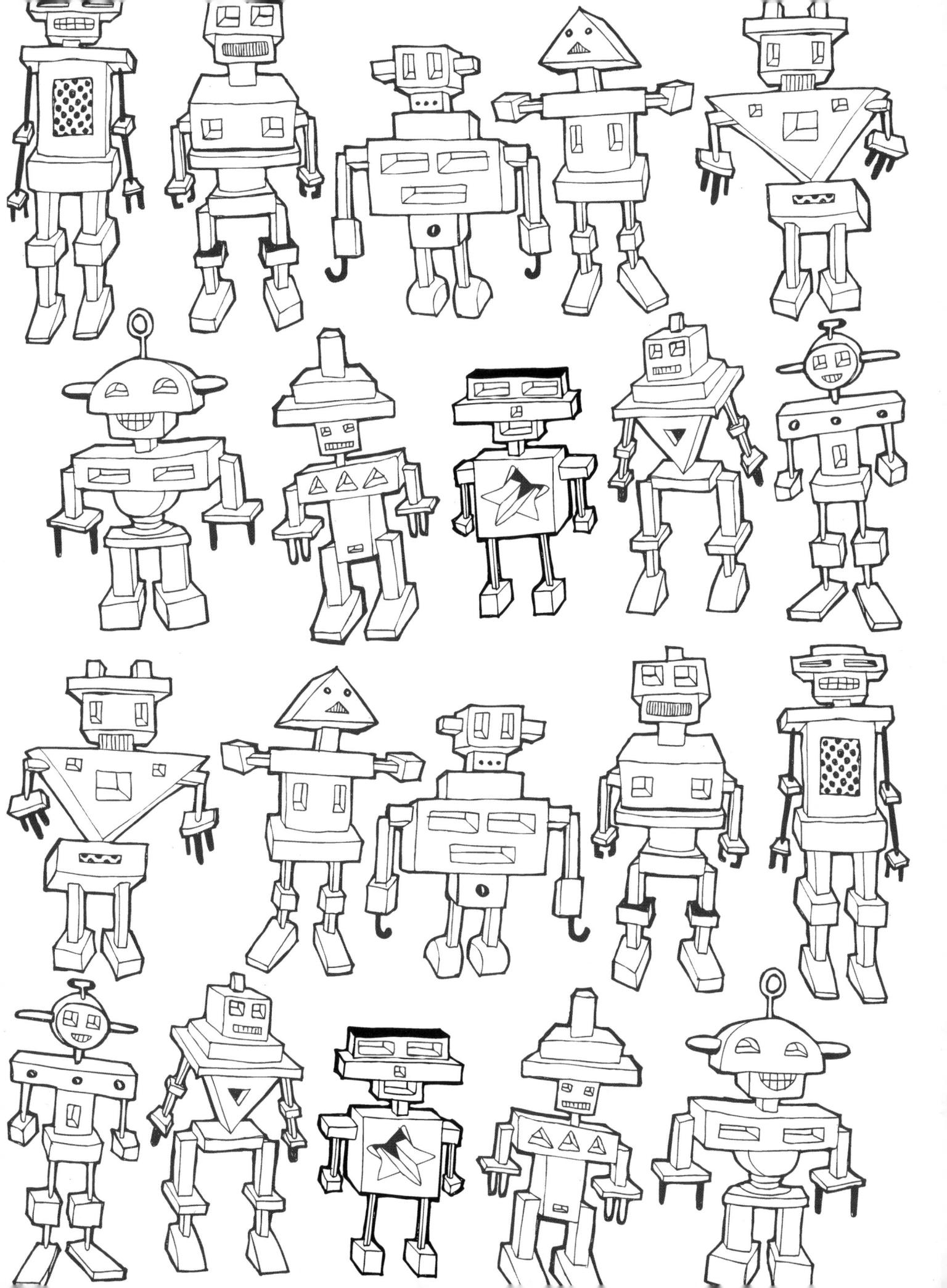

					*		

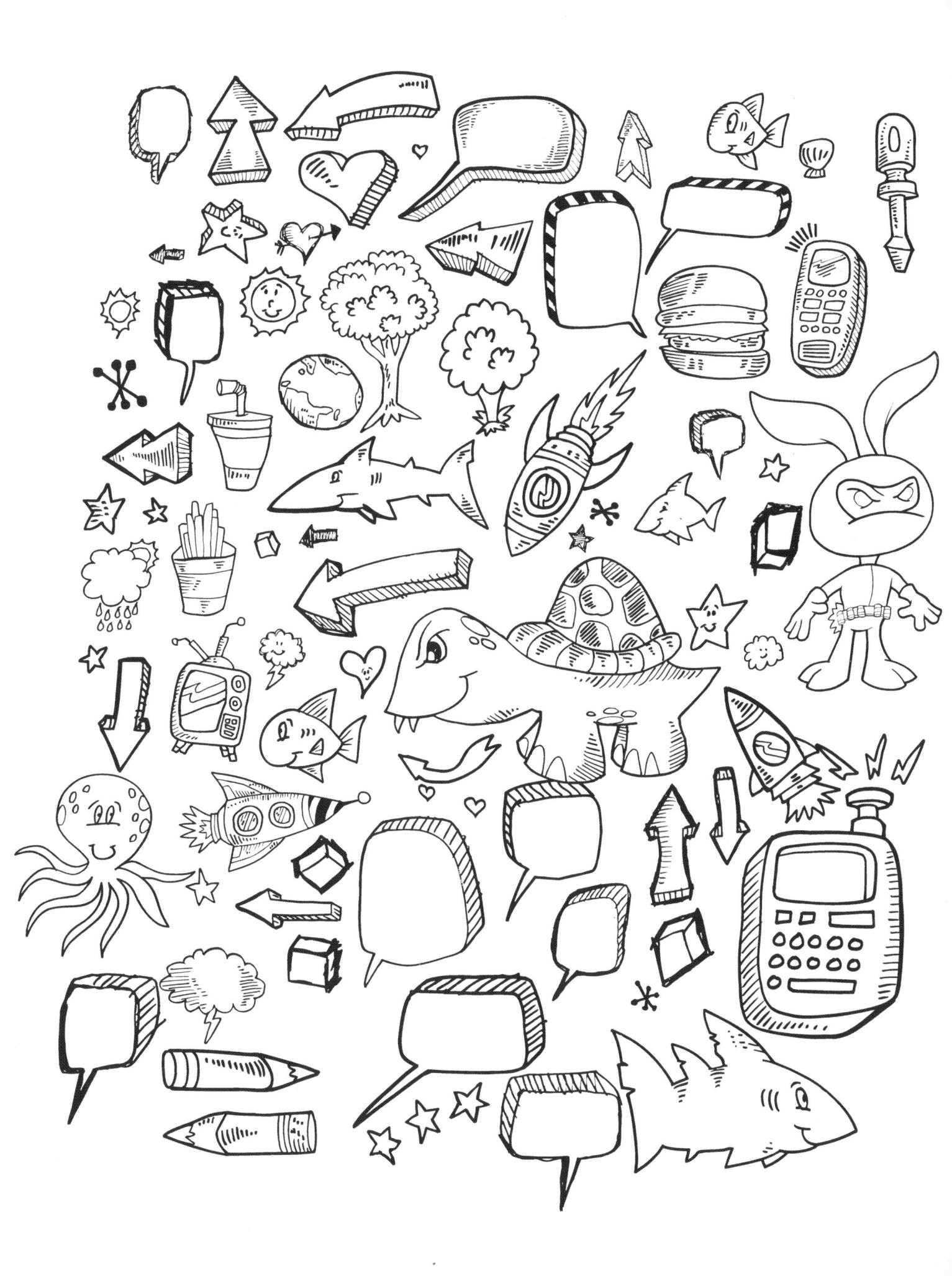

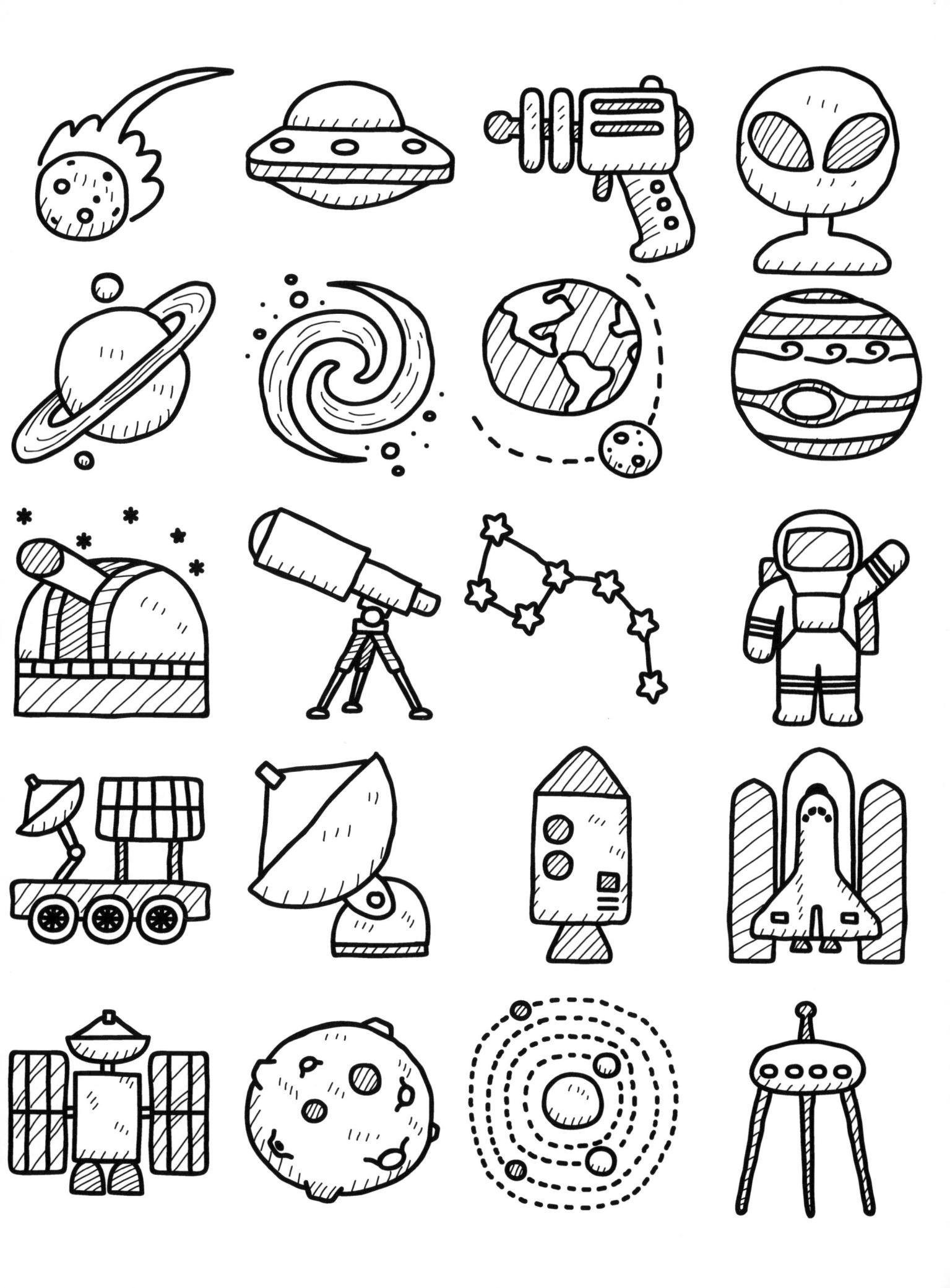

			r

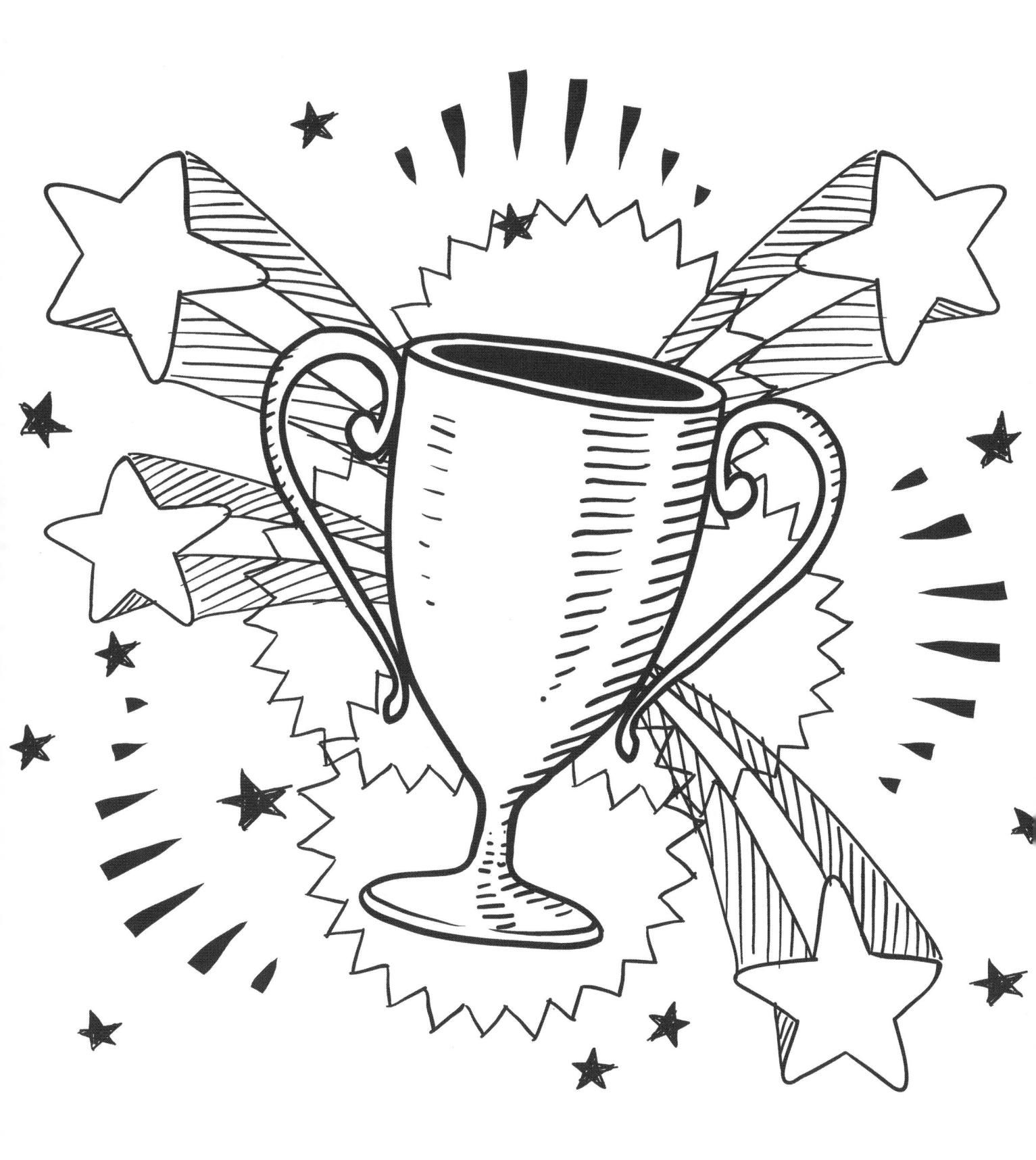

	A Commission of the Commission			

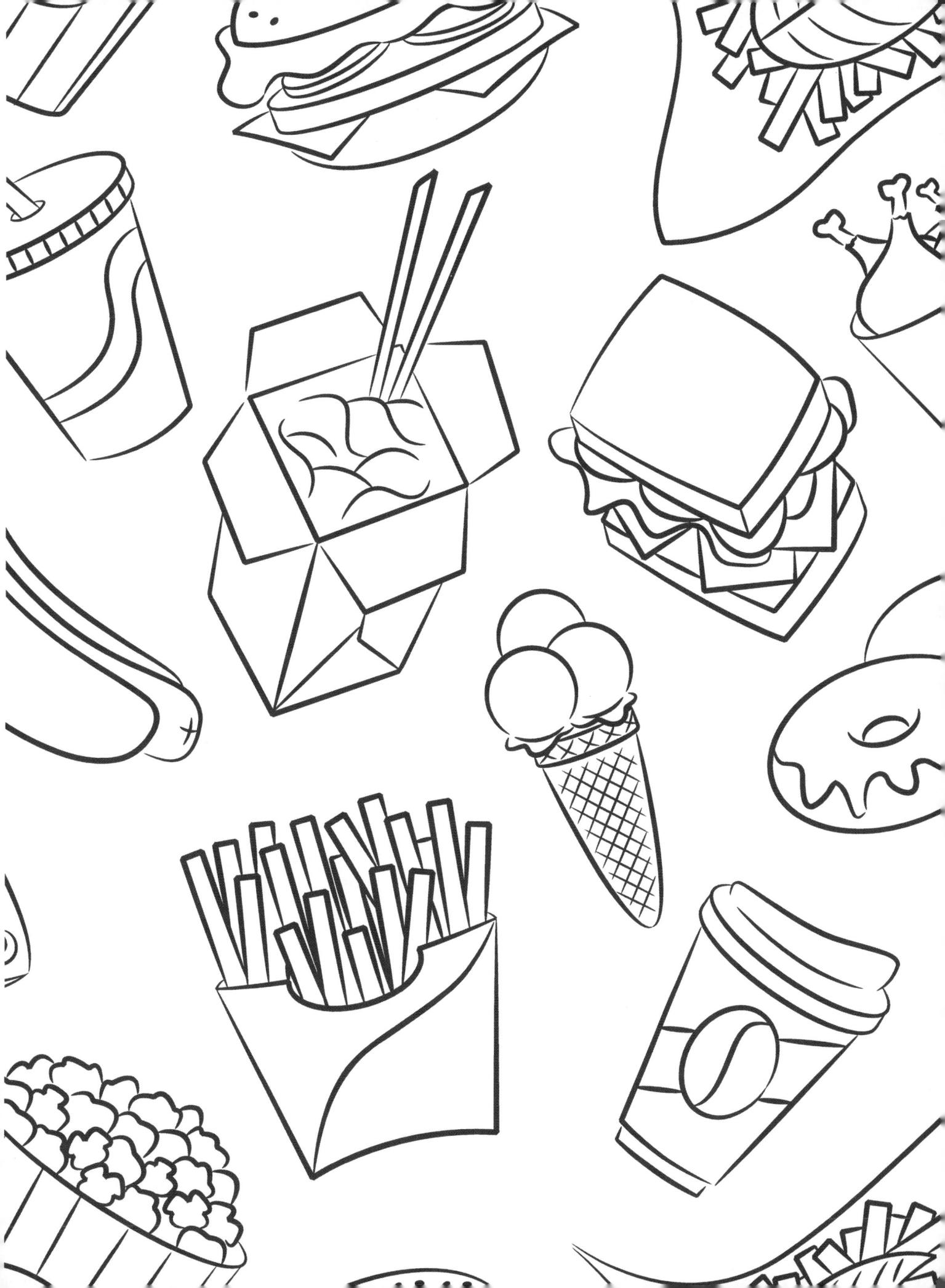

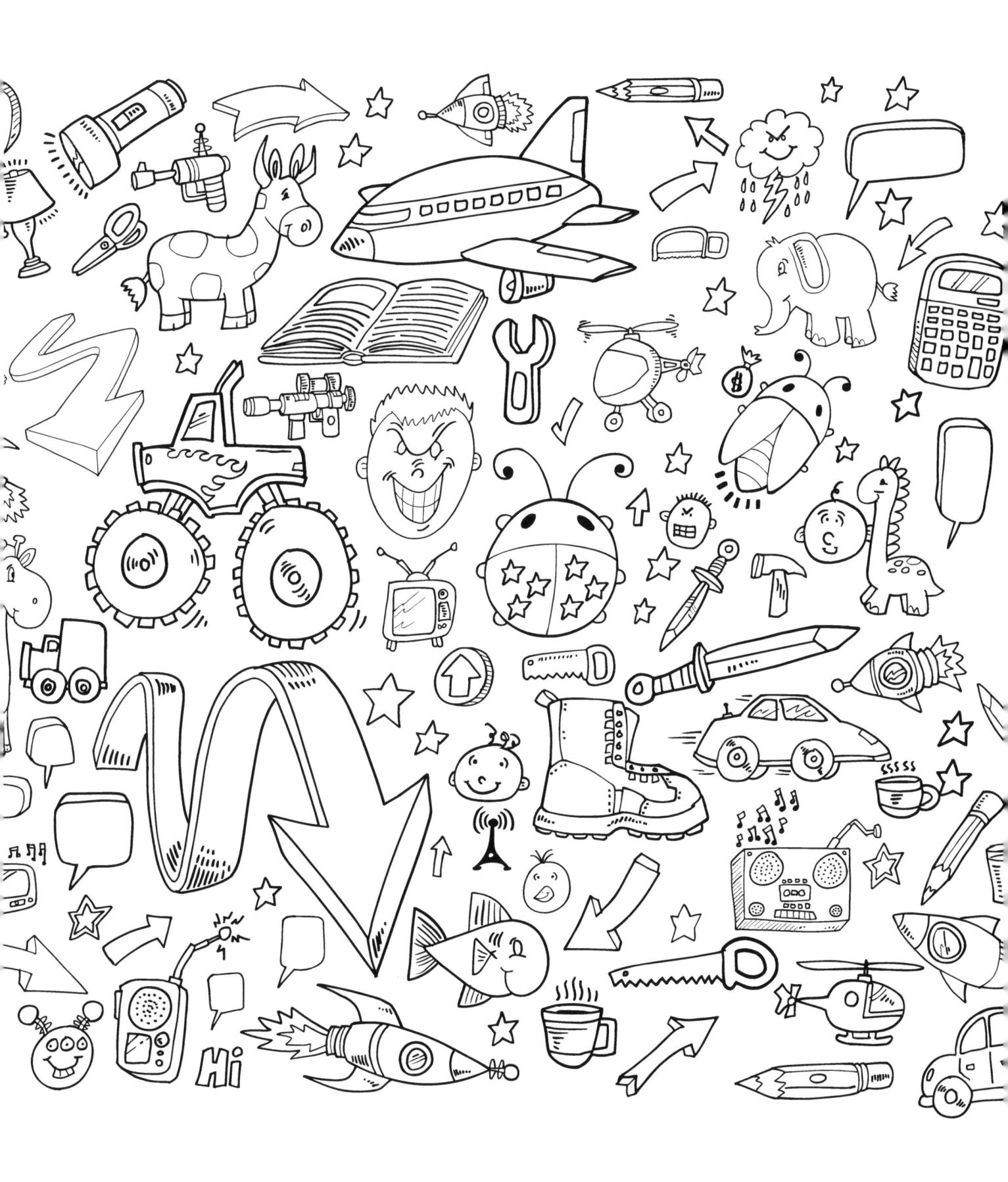

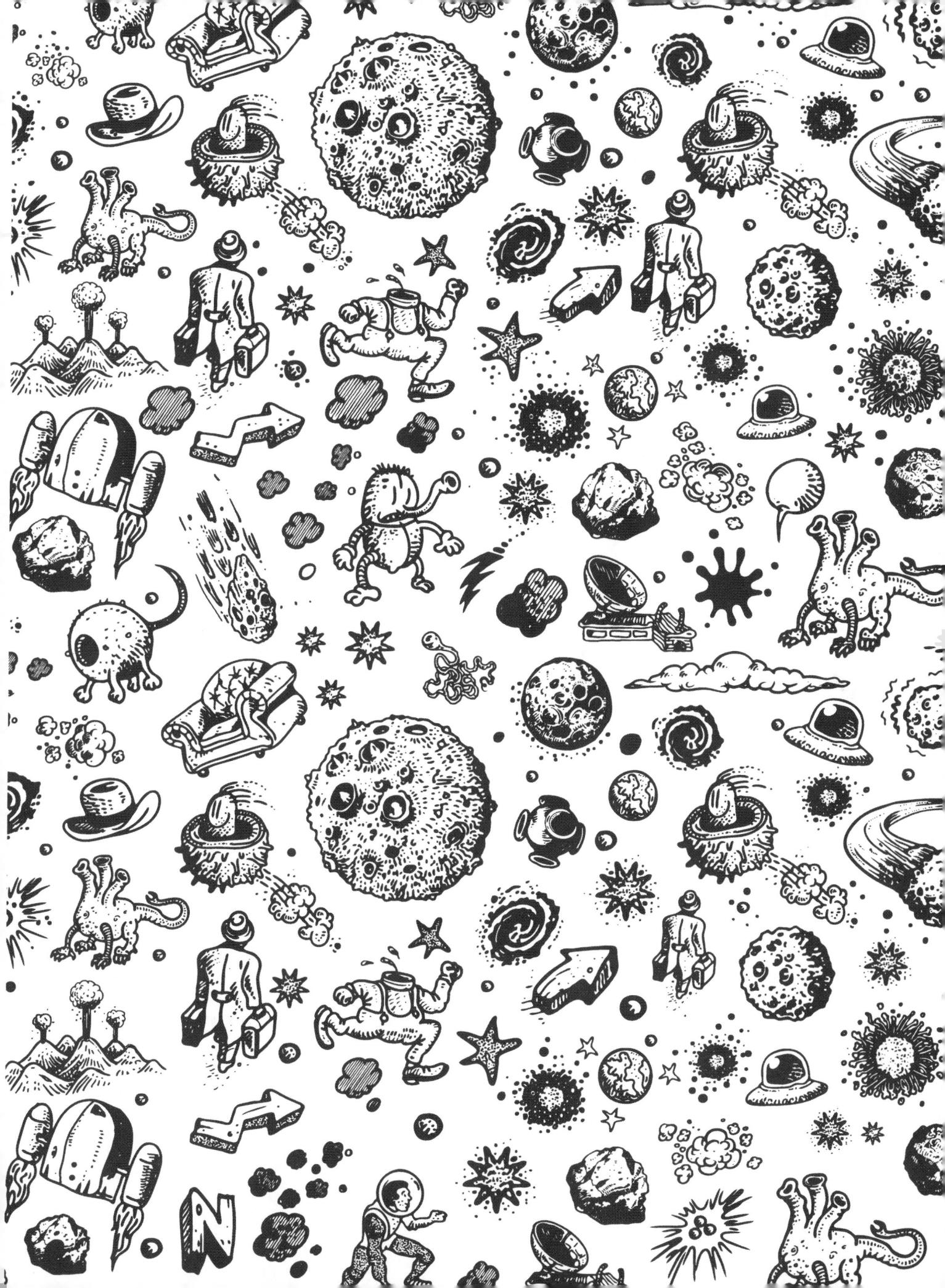

Salar.		No. of the same of the same		a - 114 jour		Water to a second			

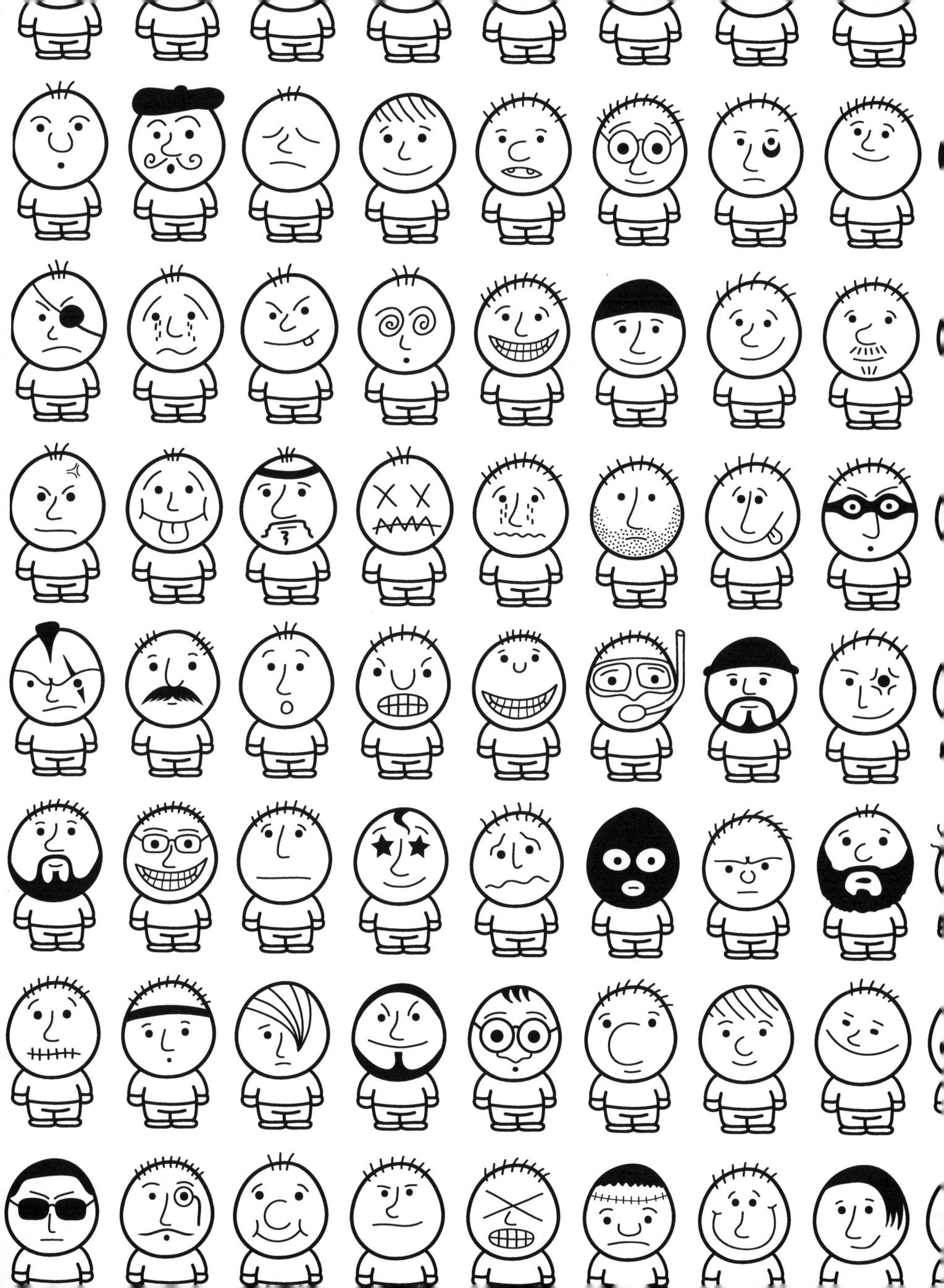

Name of the second				

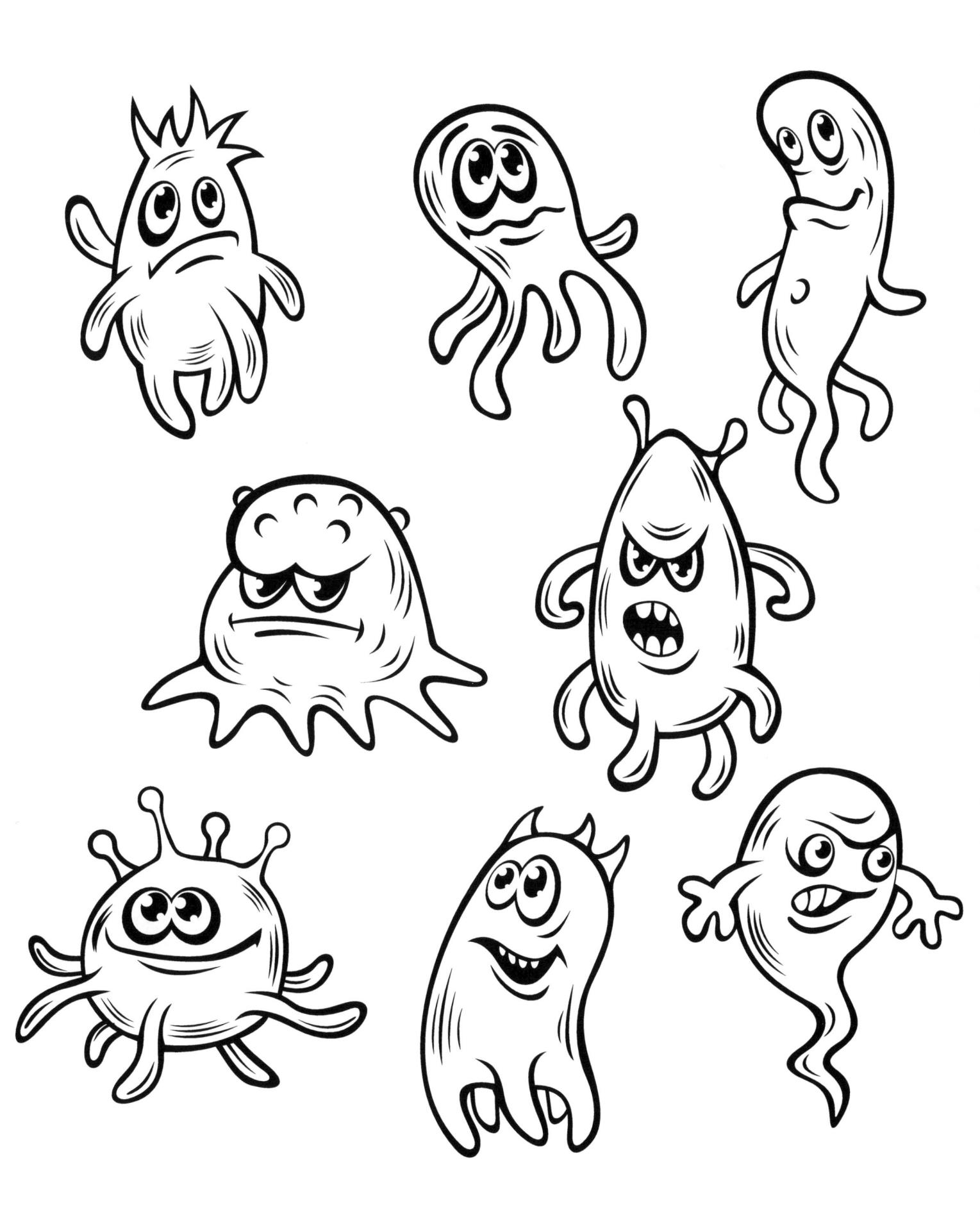

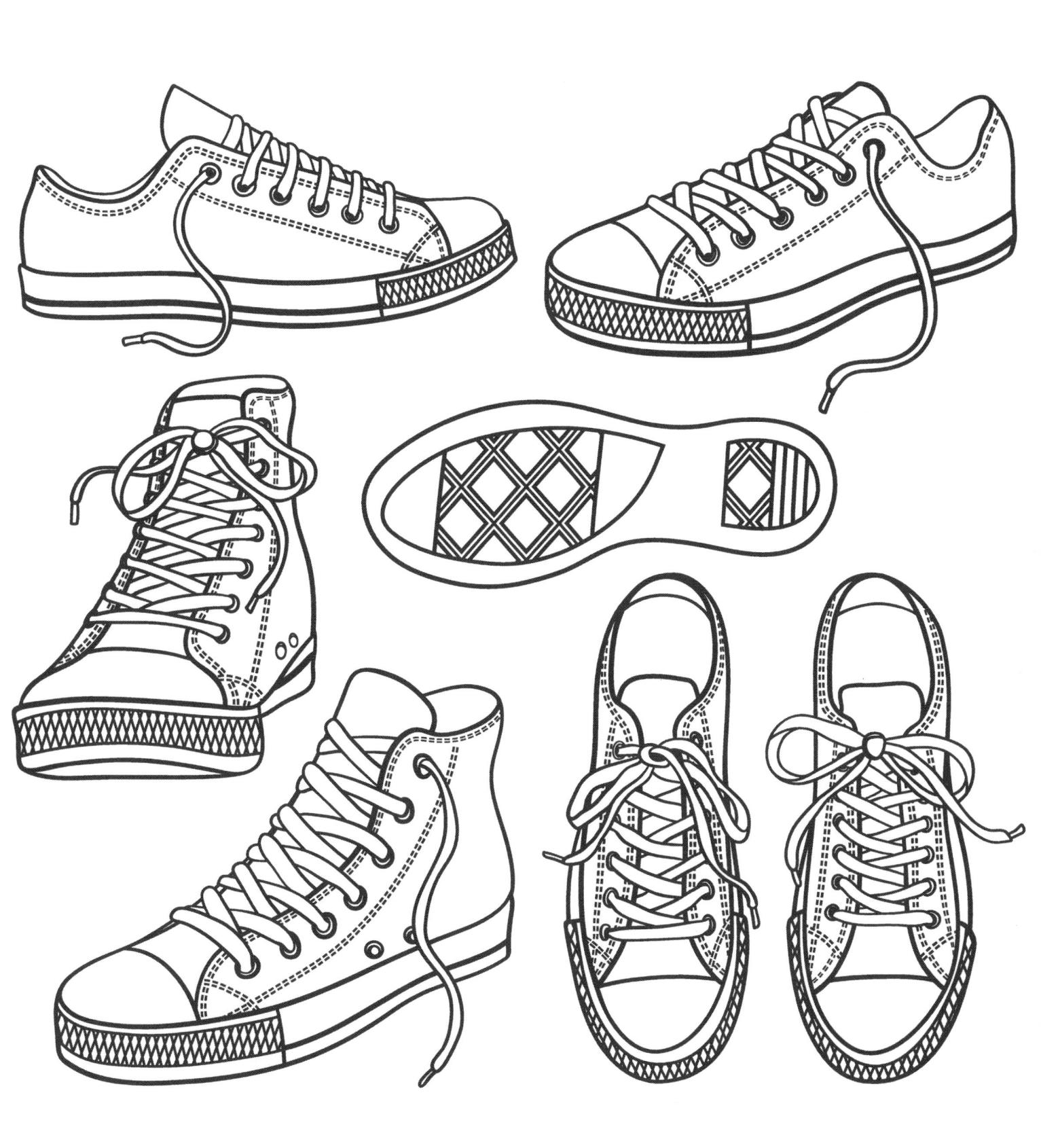

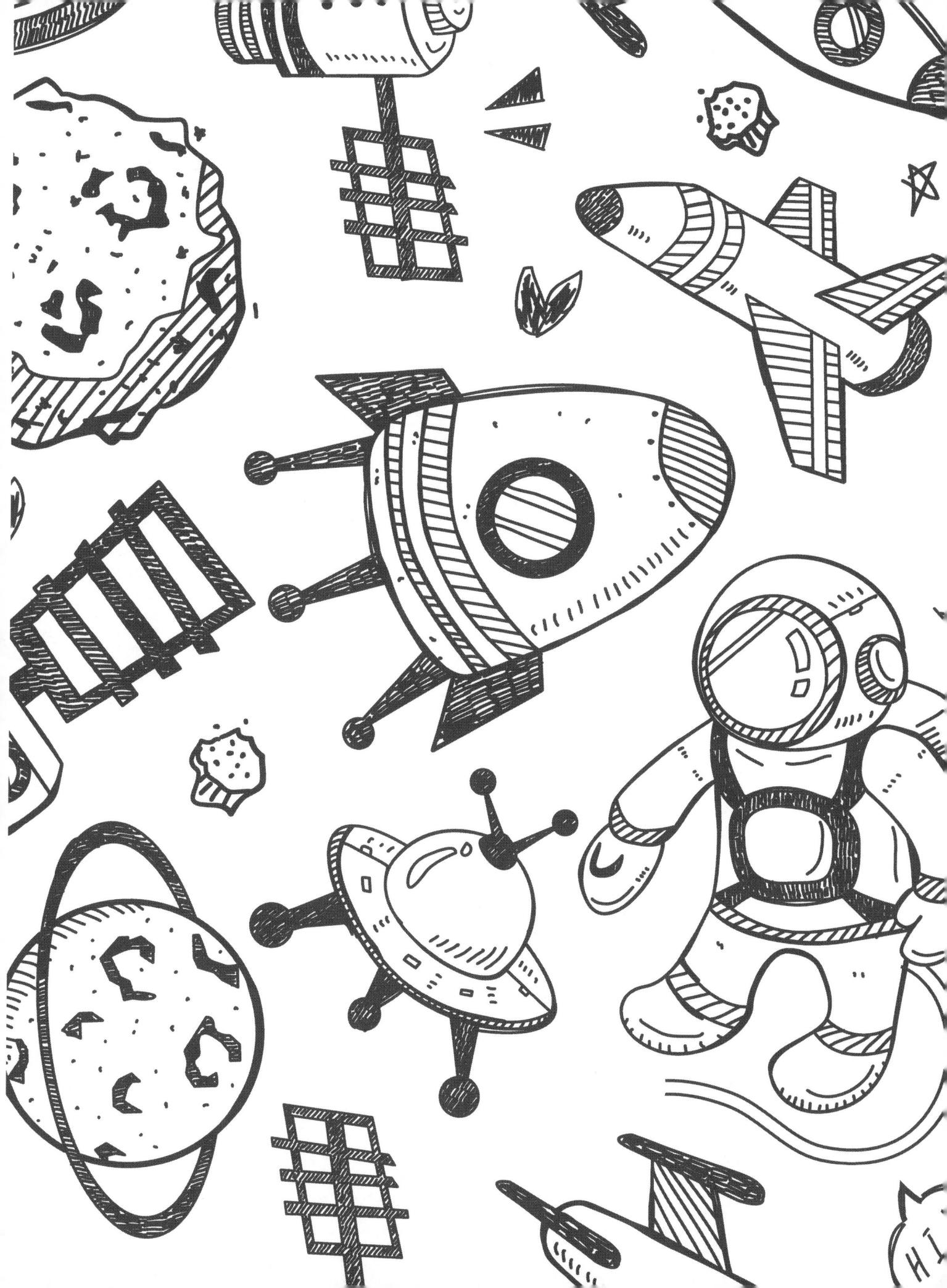

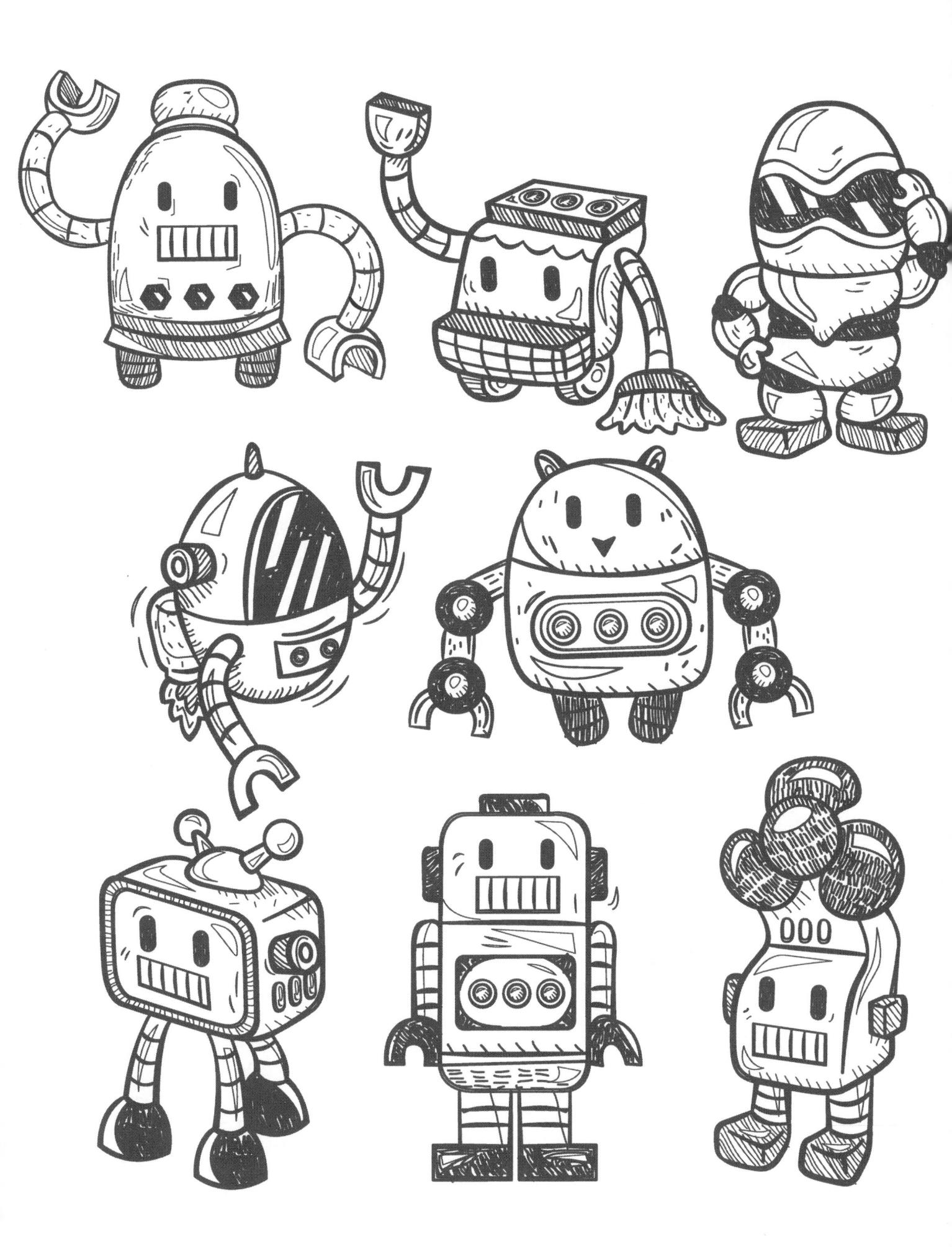

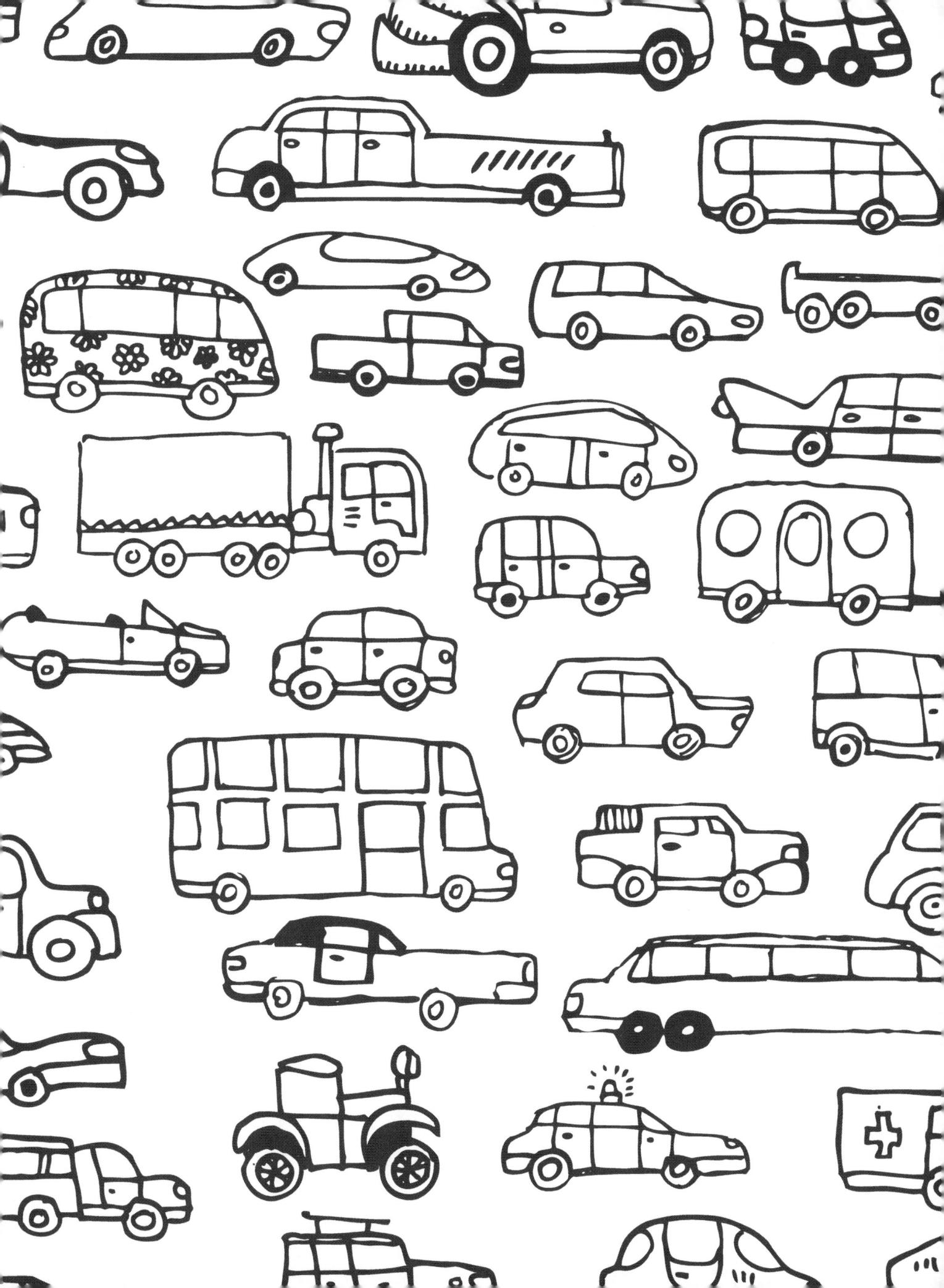

	33							

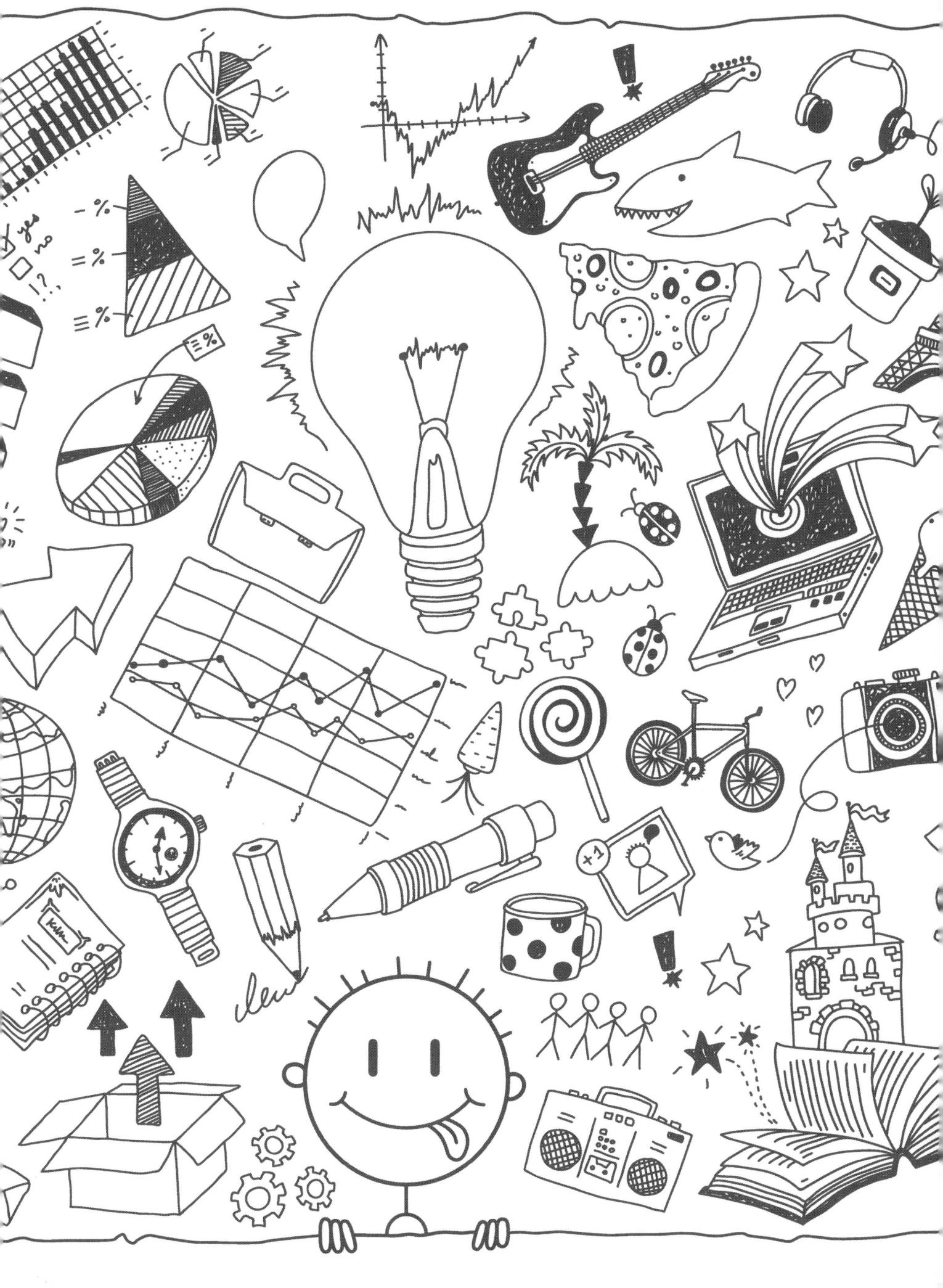

				,				
			×					
				All the second of the second				

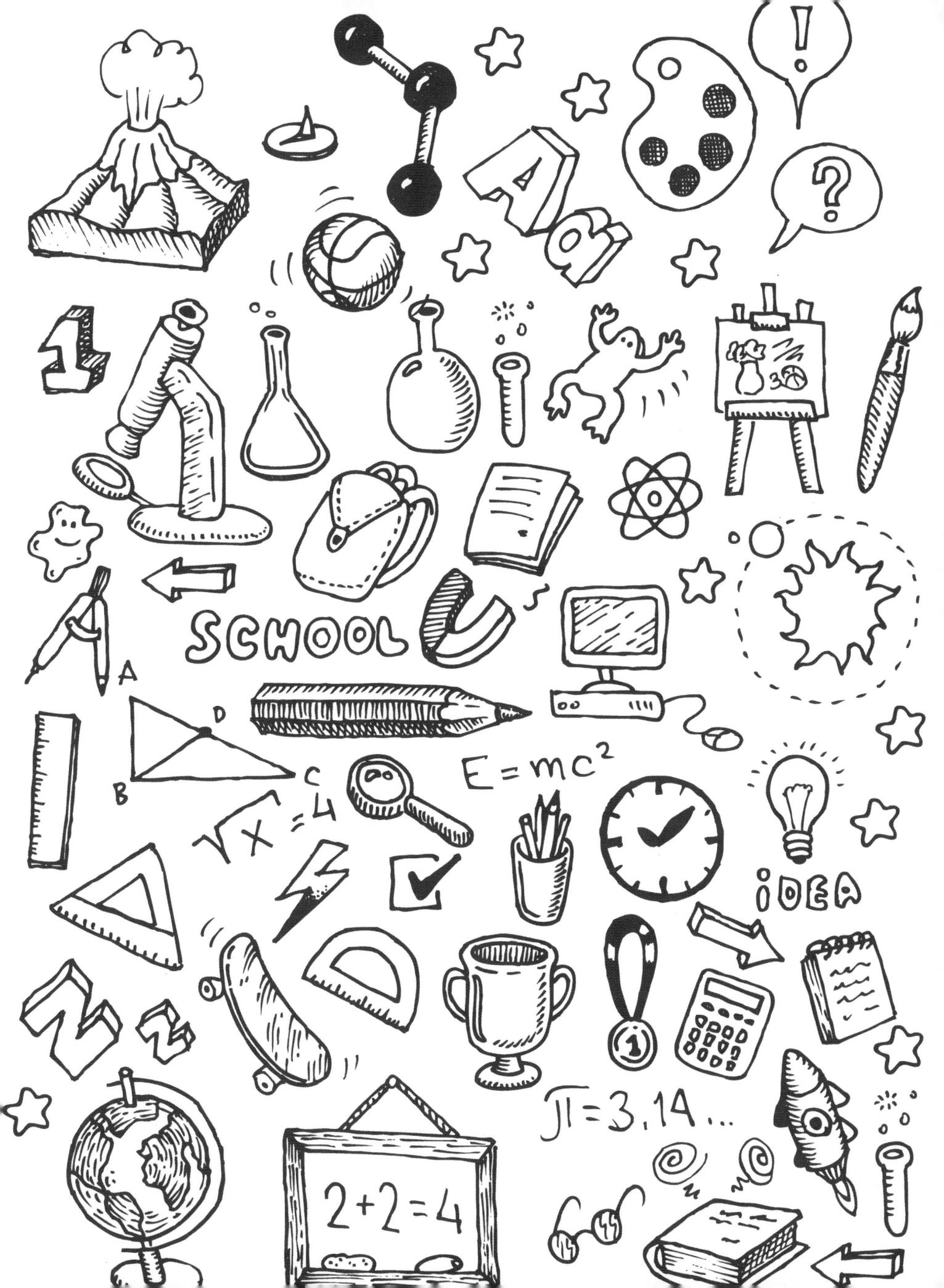

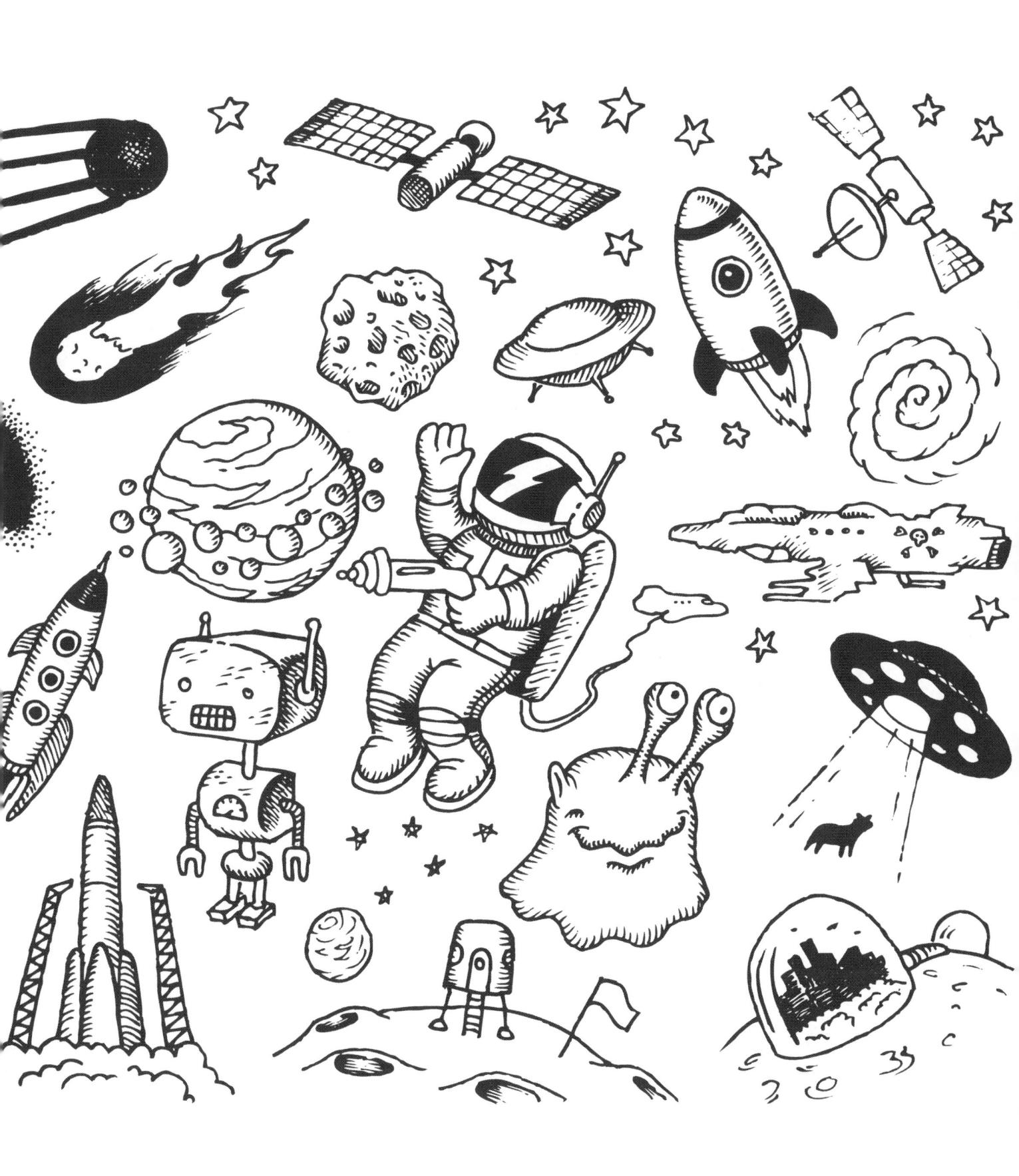

					N. A. A. S.		
P.							
	N a						

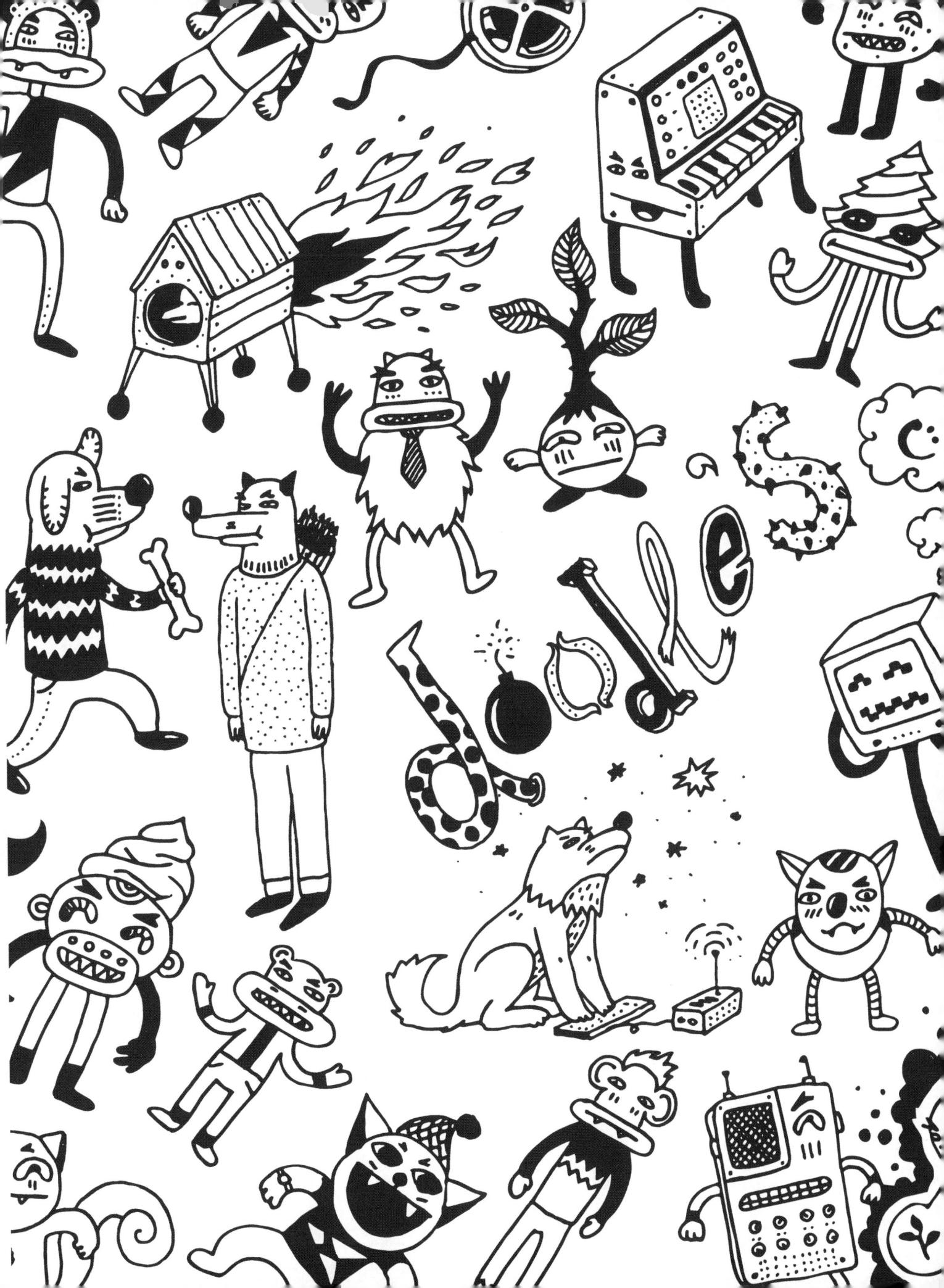

•				
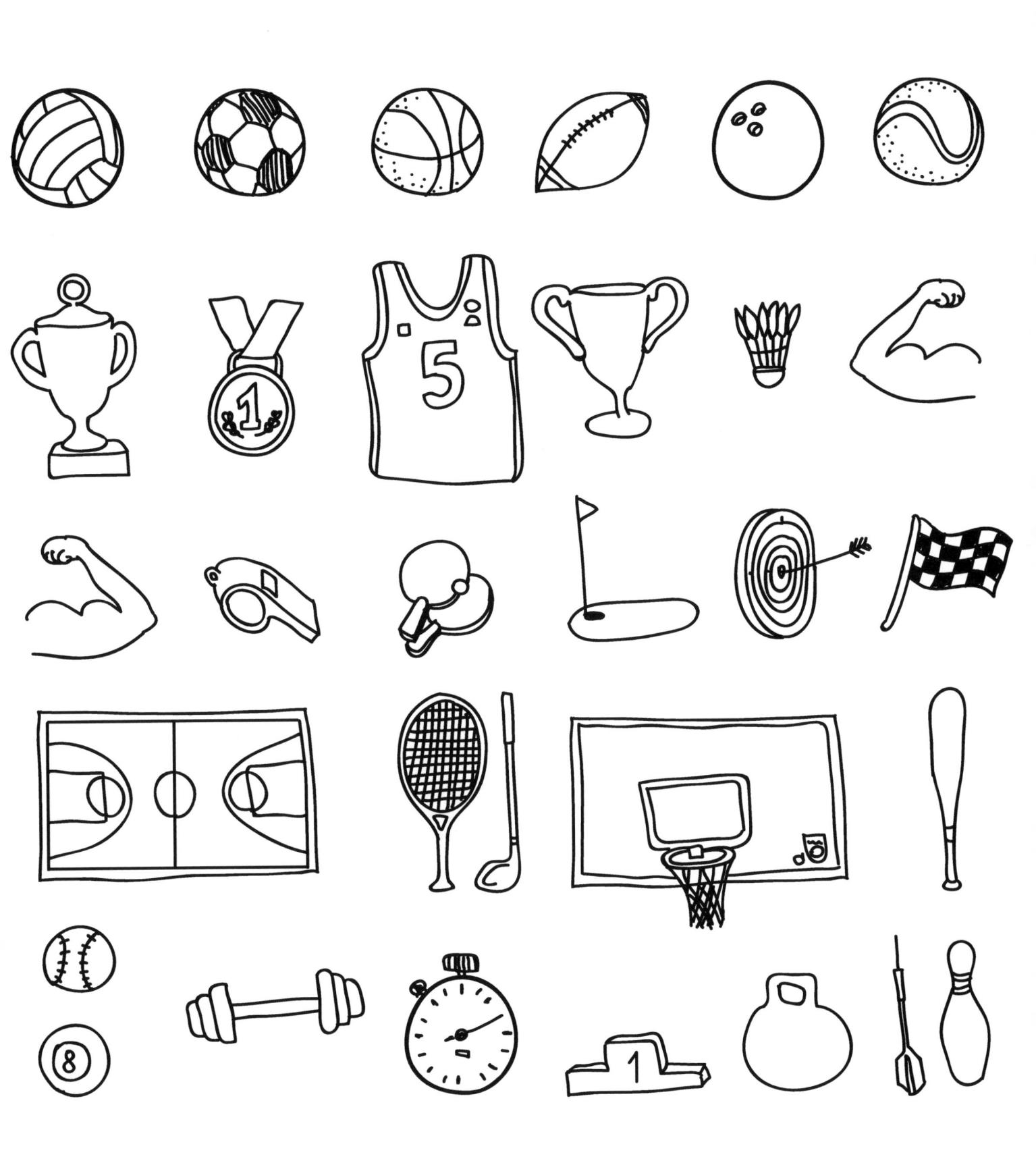

•
2019년 - 19 - 19 1일 전문 19 1일 1 1 125 전 17 1일 1 1 1 1 1 1 1 1 1 1 1 1 1 1 1 1 1

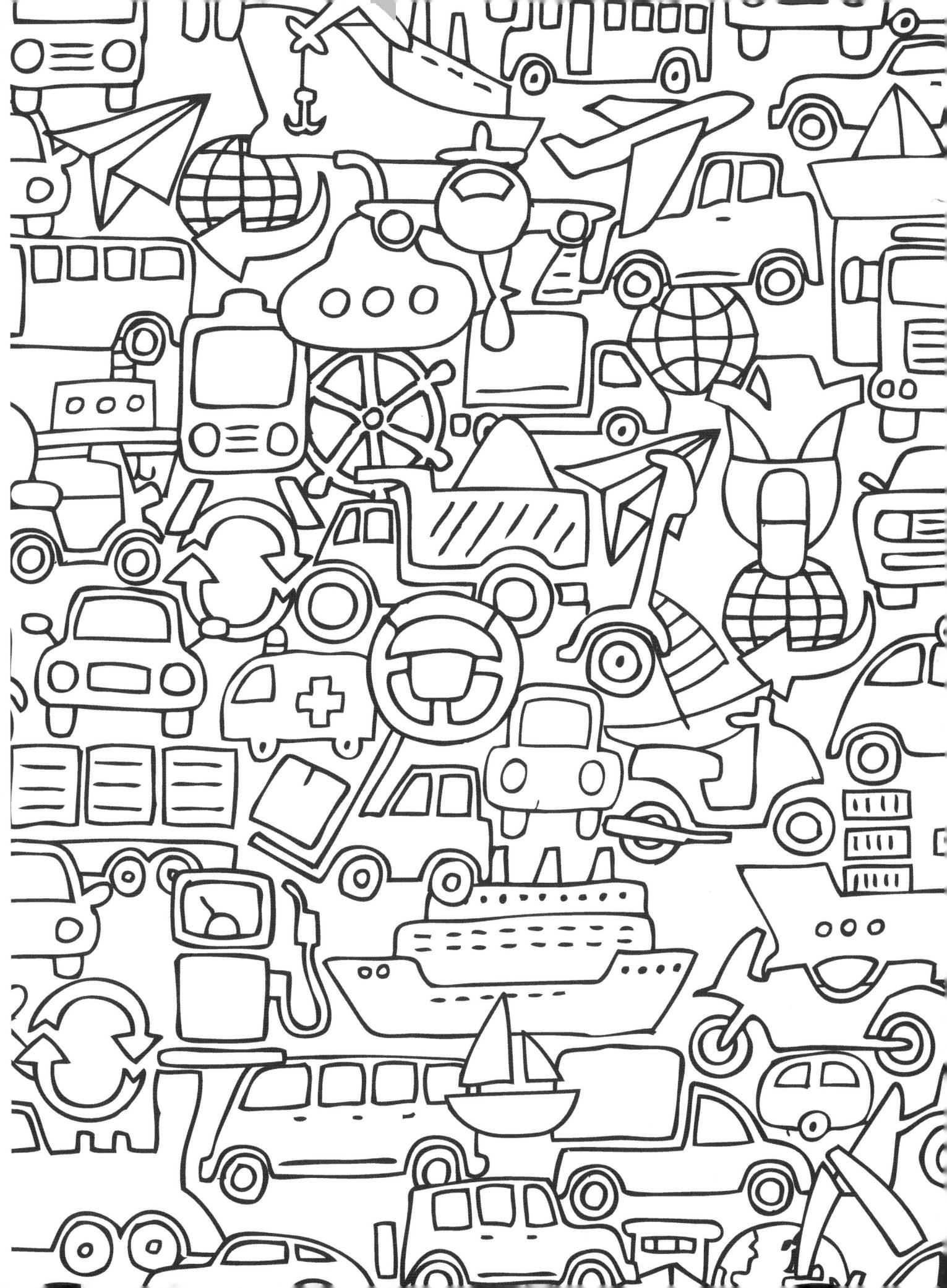

7.				

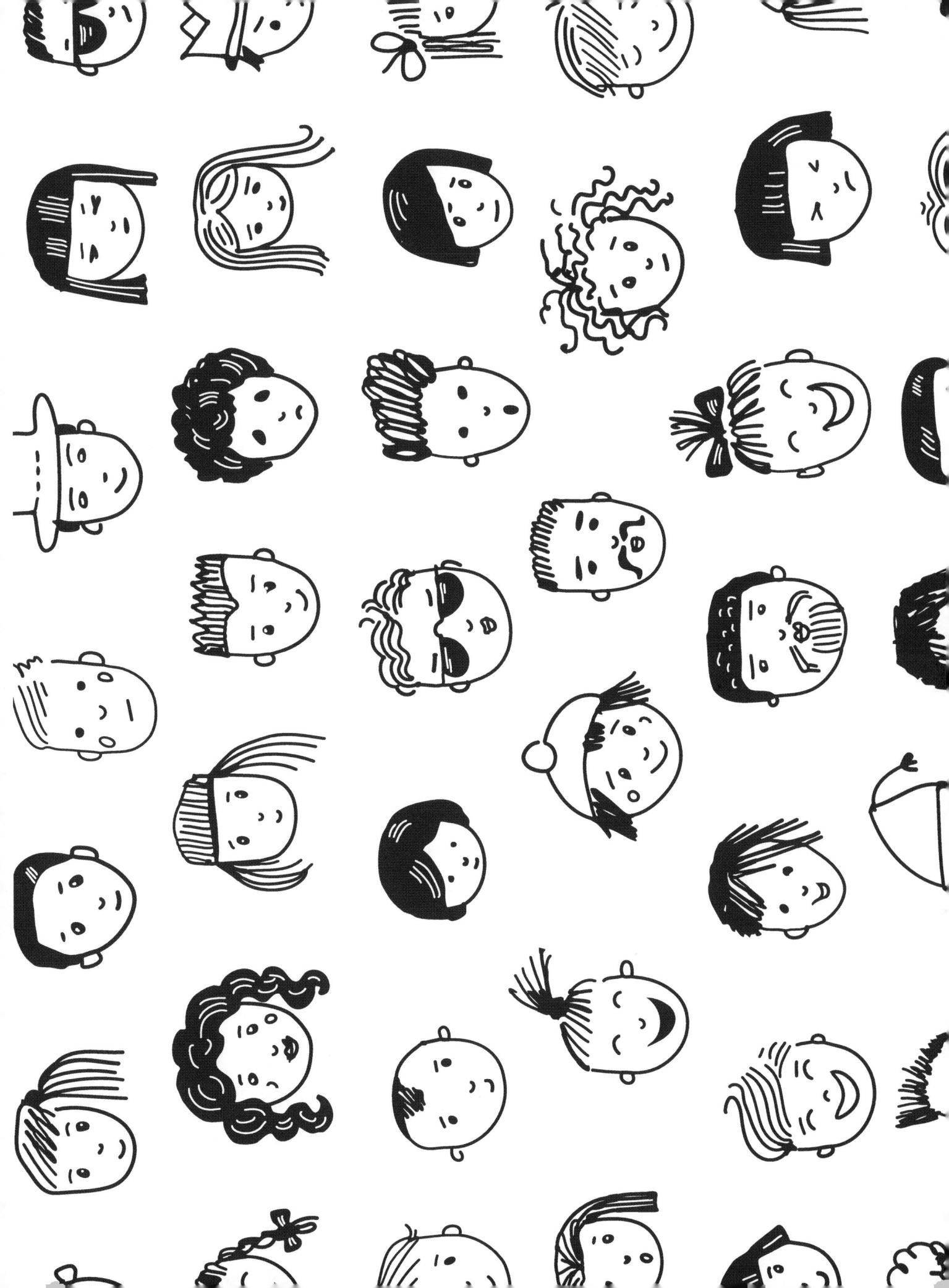

	man.			
n .				
z.				
				*

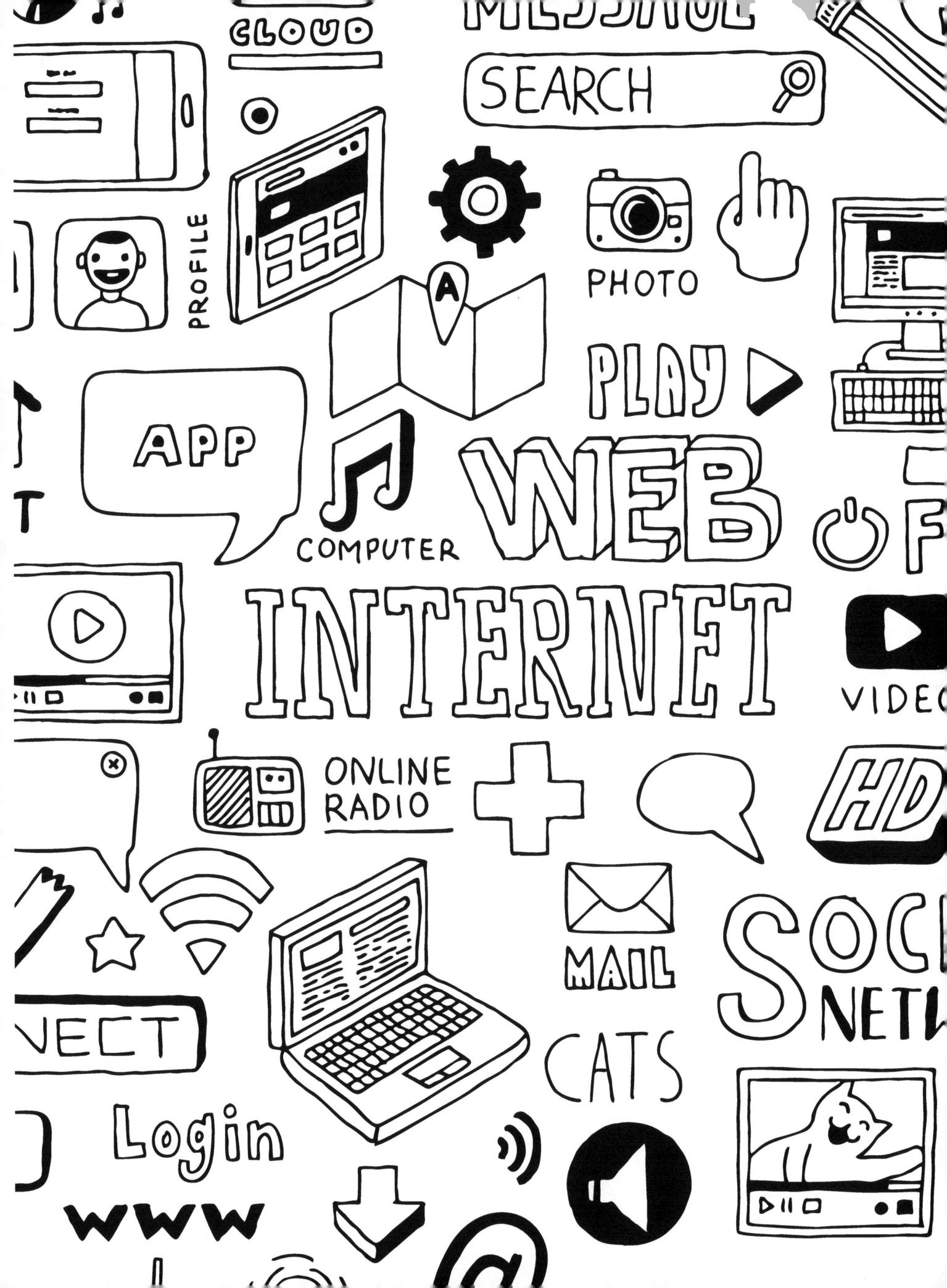

Maria de la companya				

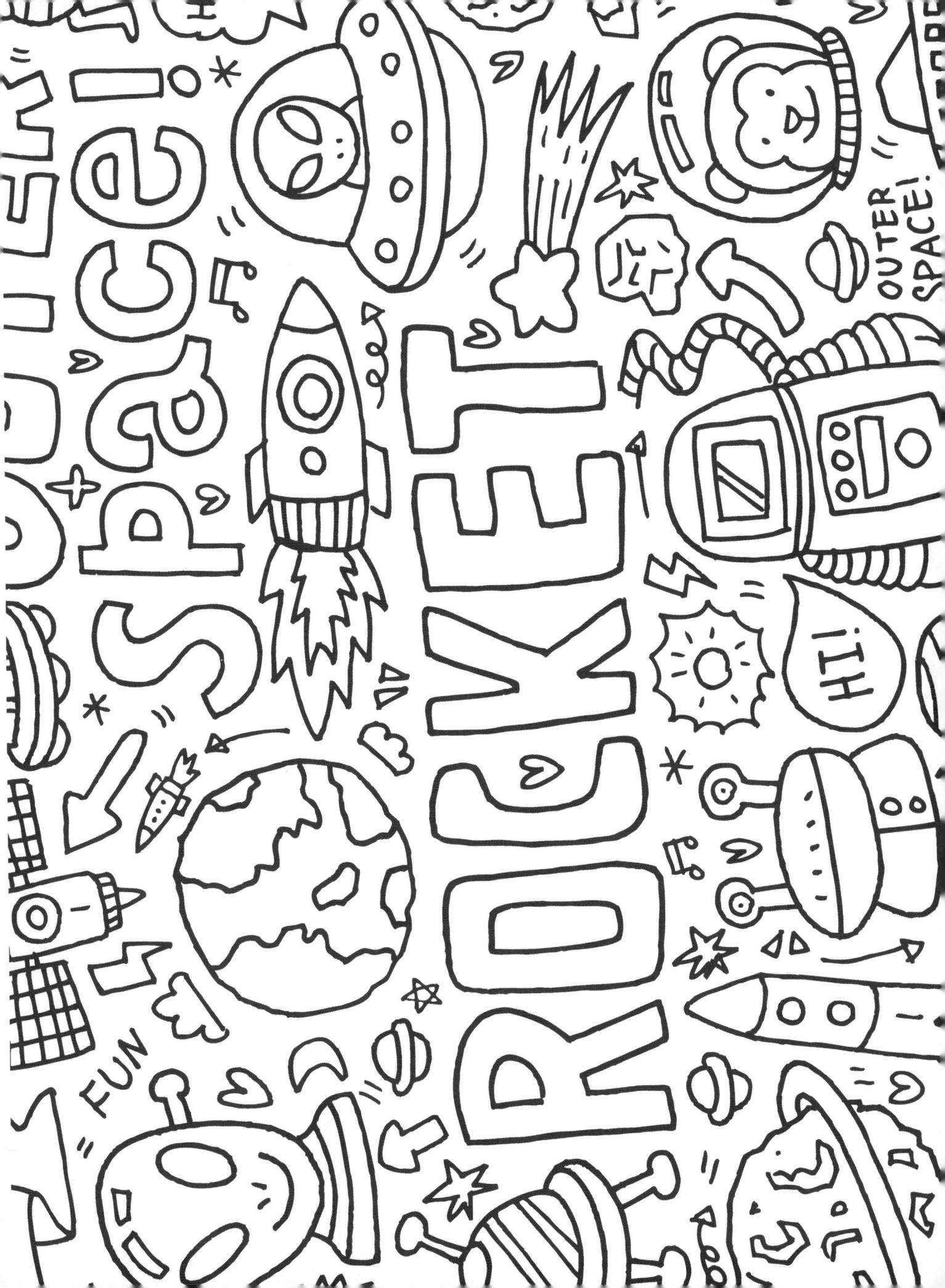

Prince Table 1	Section 1	Transfer of				

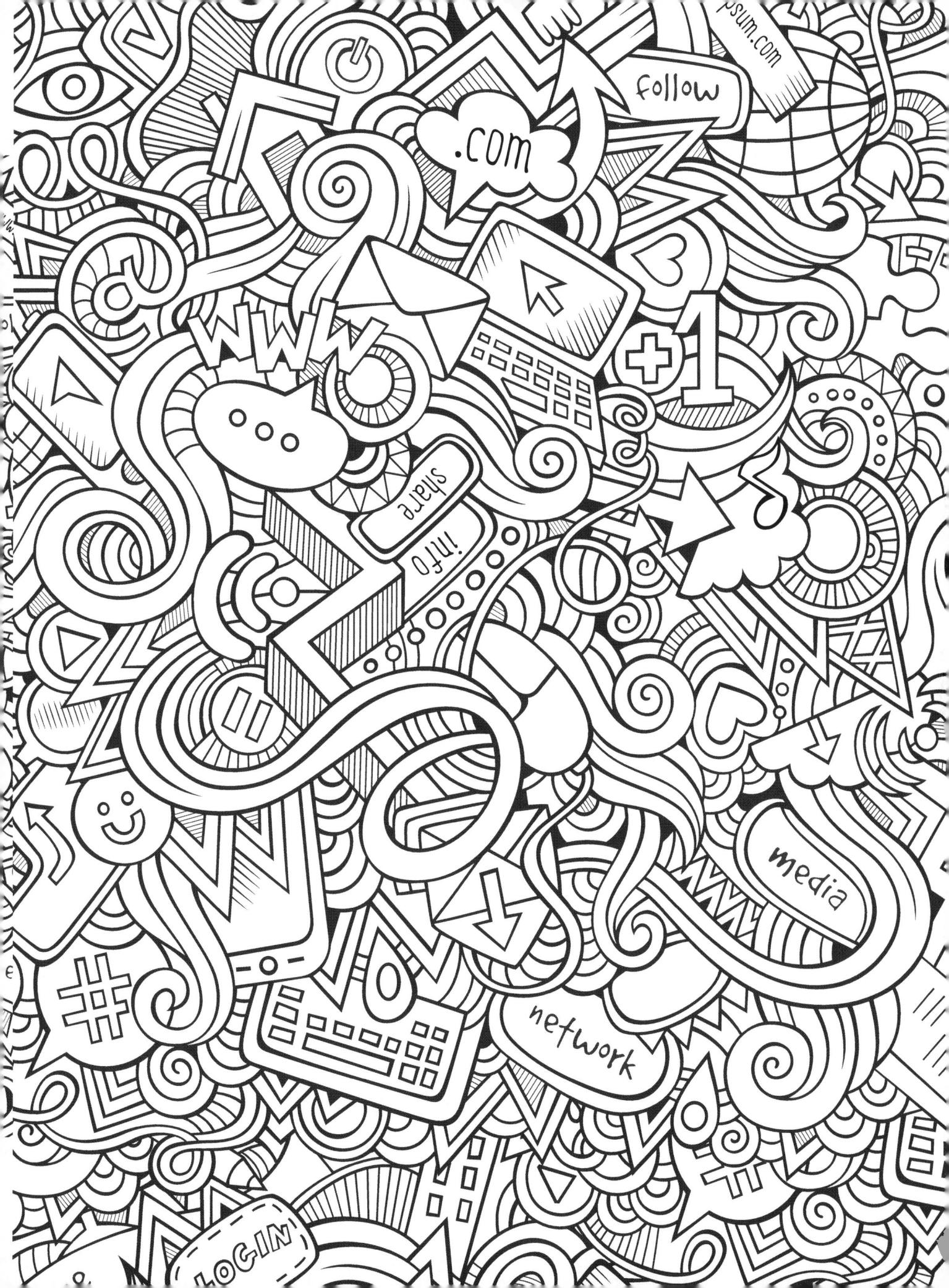

, and the second				
	and the second s			

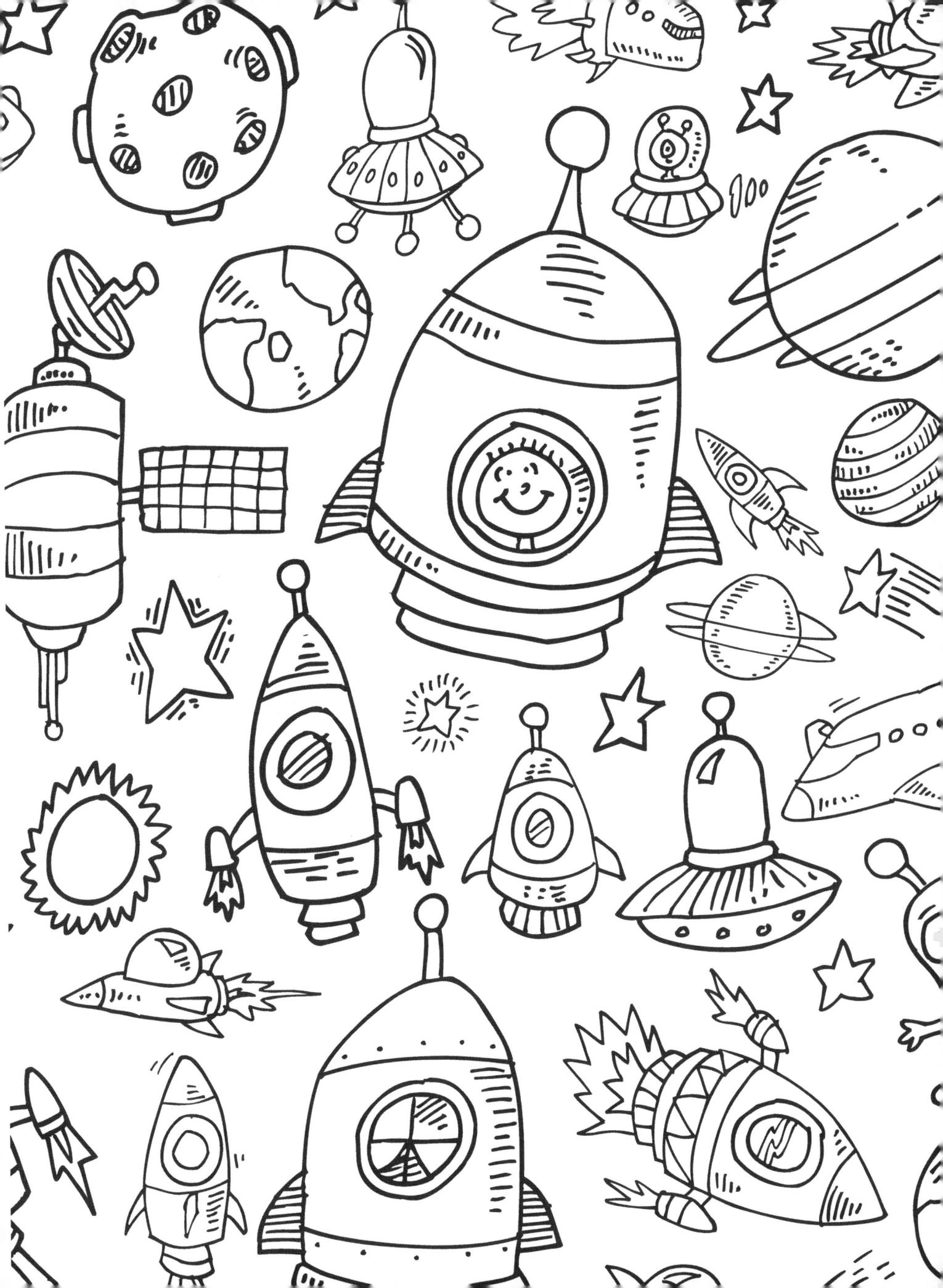

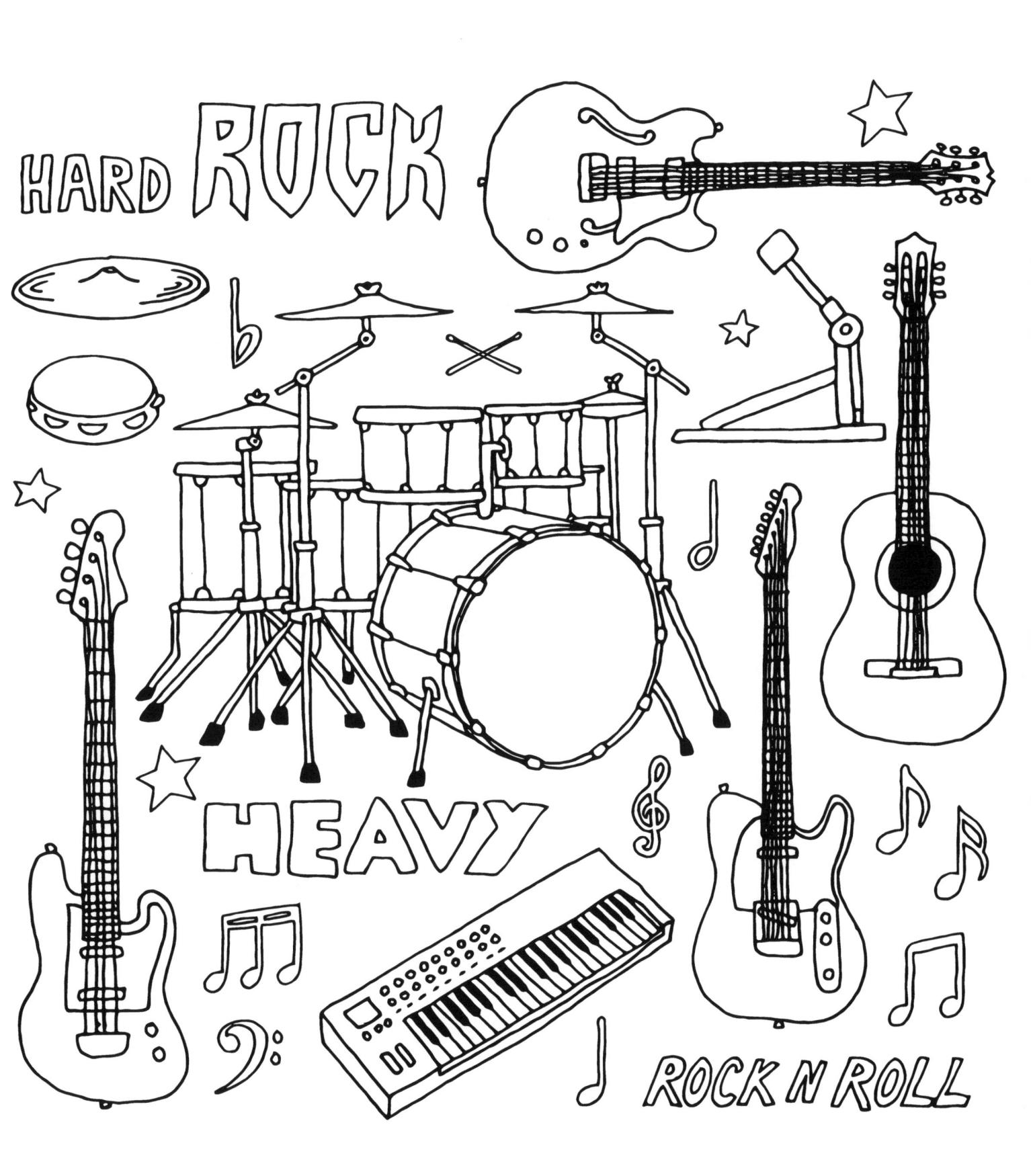

100 mm			
p.			

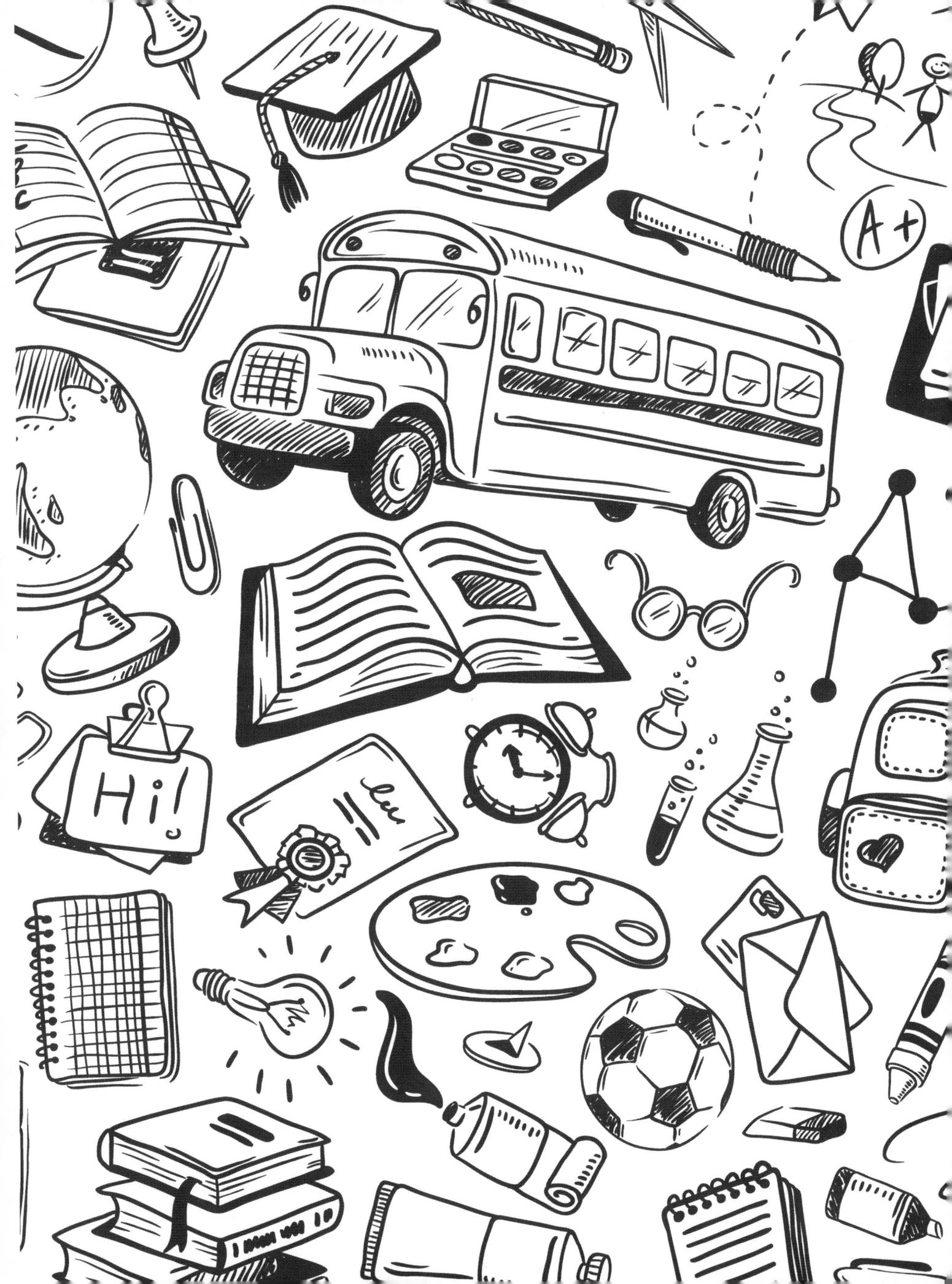

*			

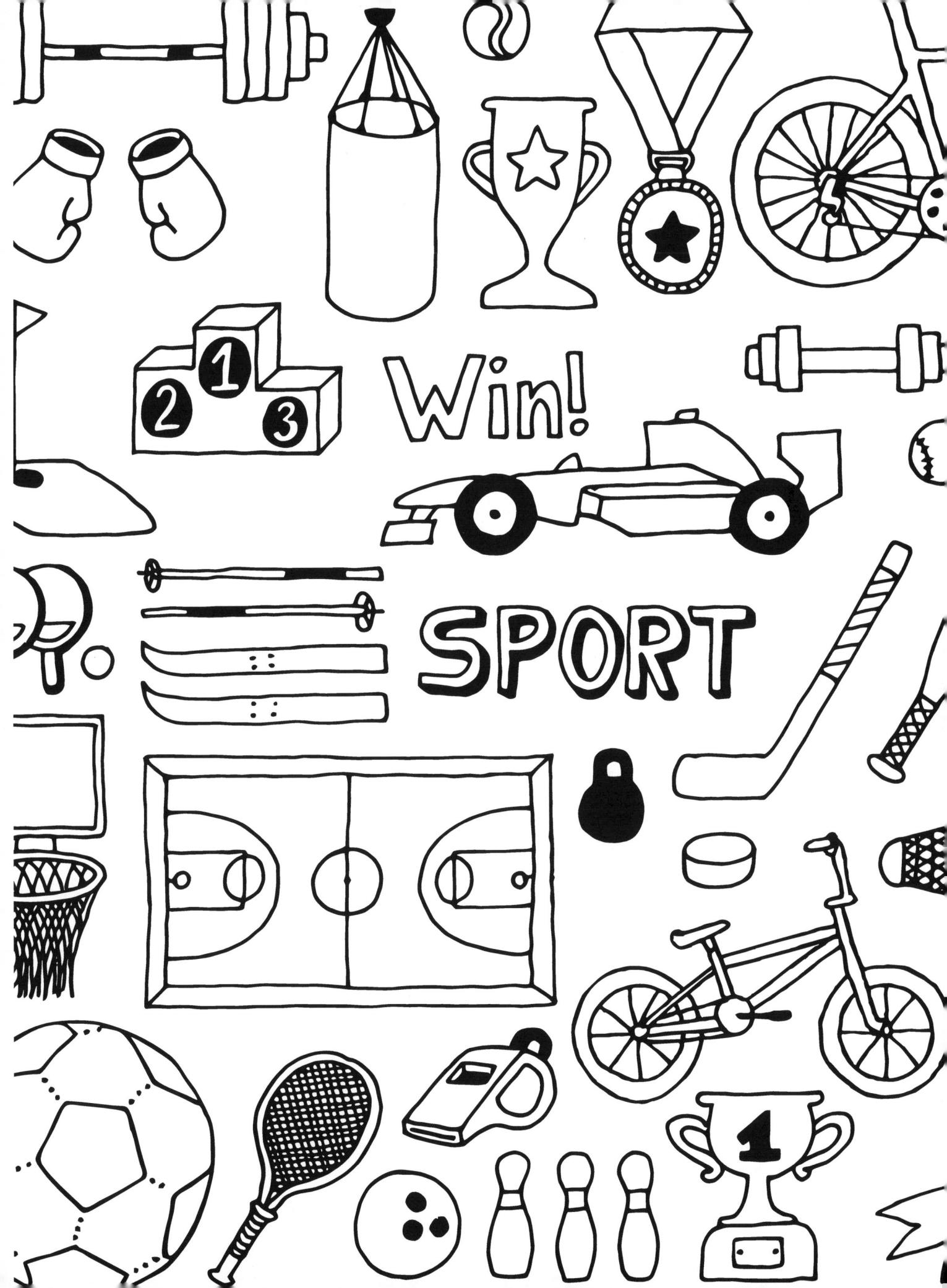

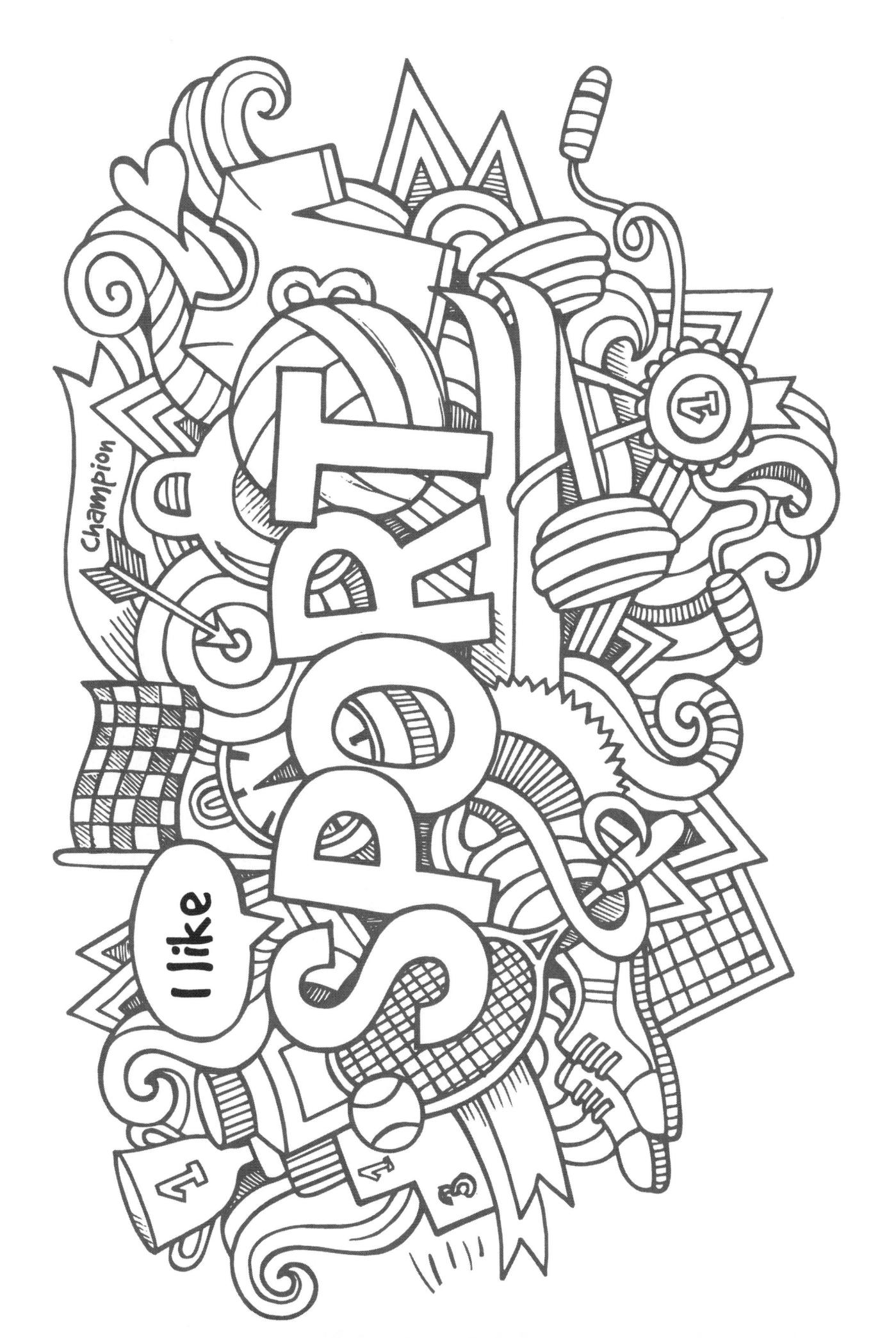

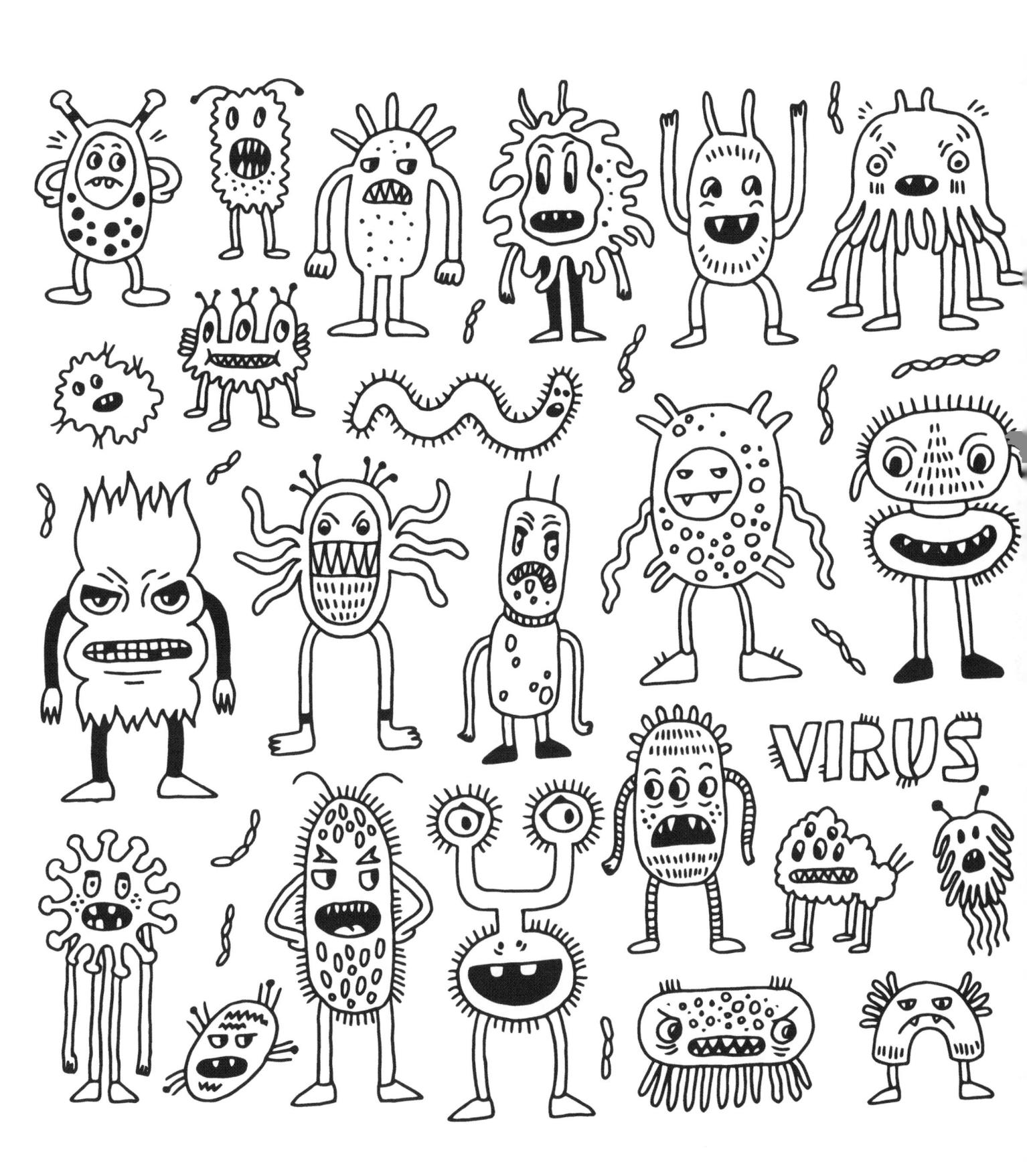

			•	
		*		

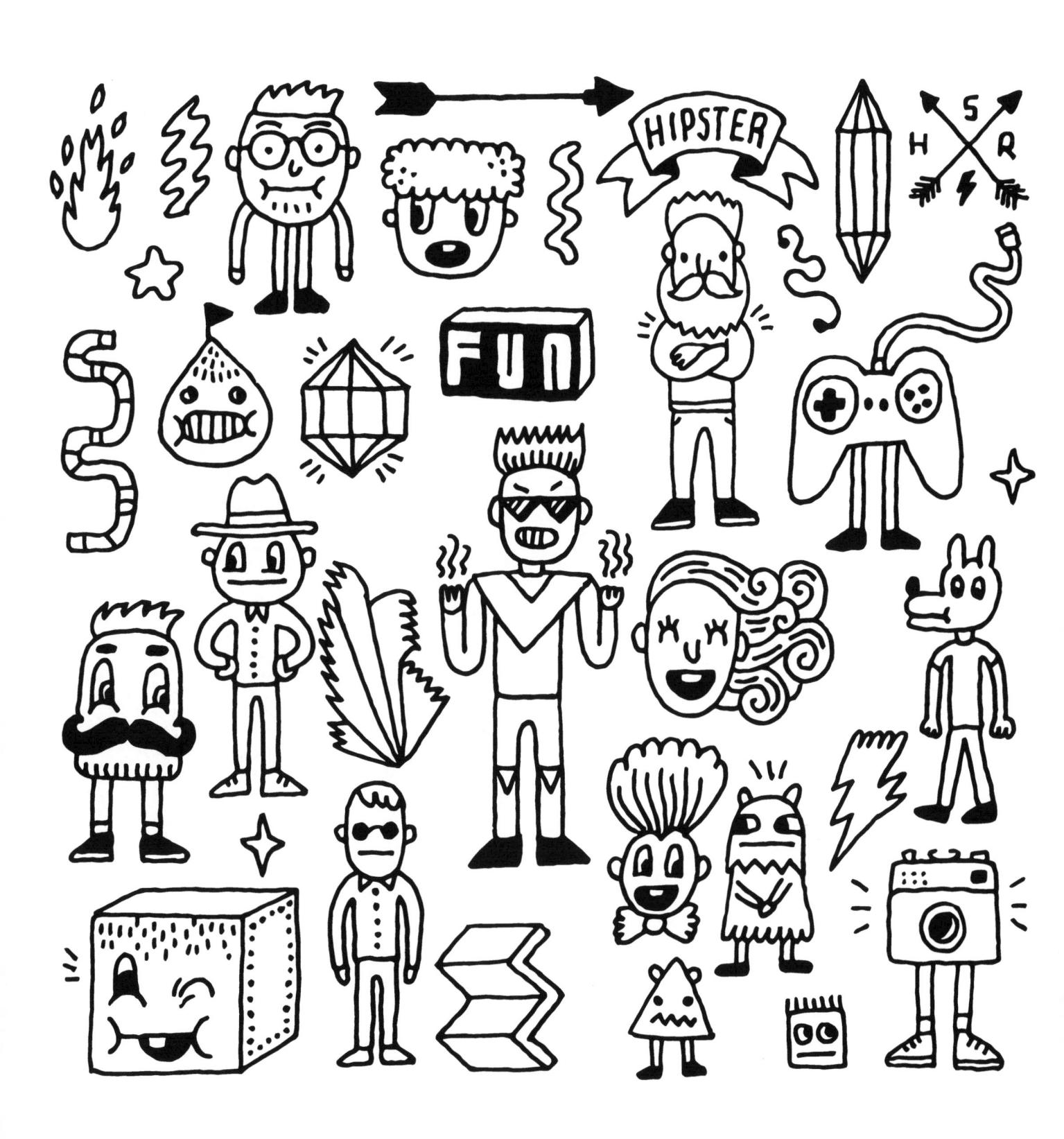

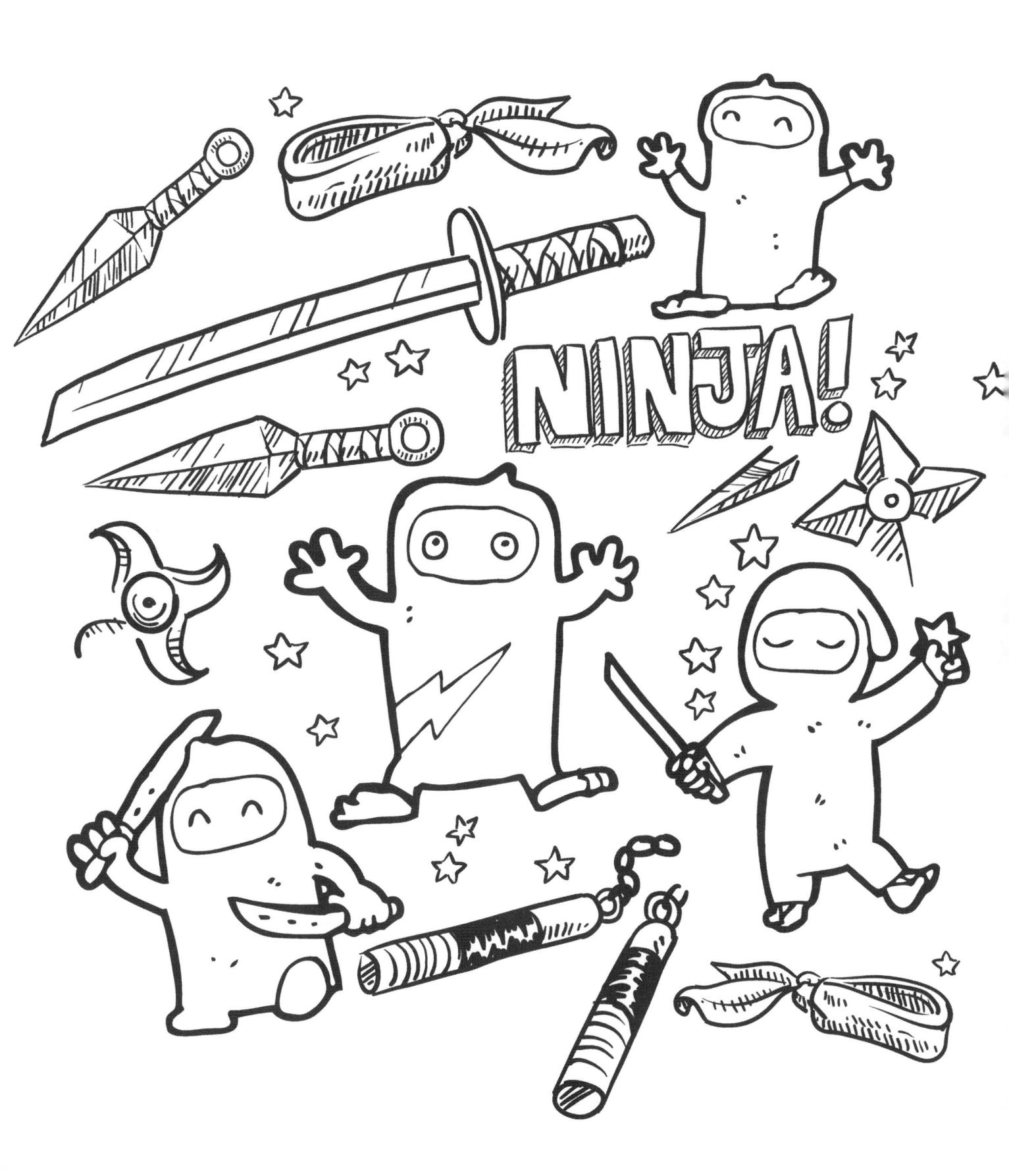

		•		
	-			
<u> </u>				